THE BIG PICTURE

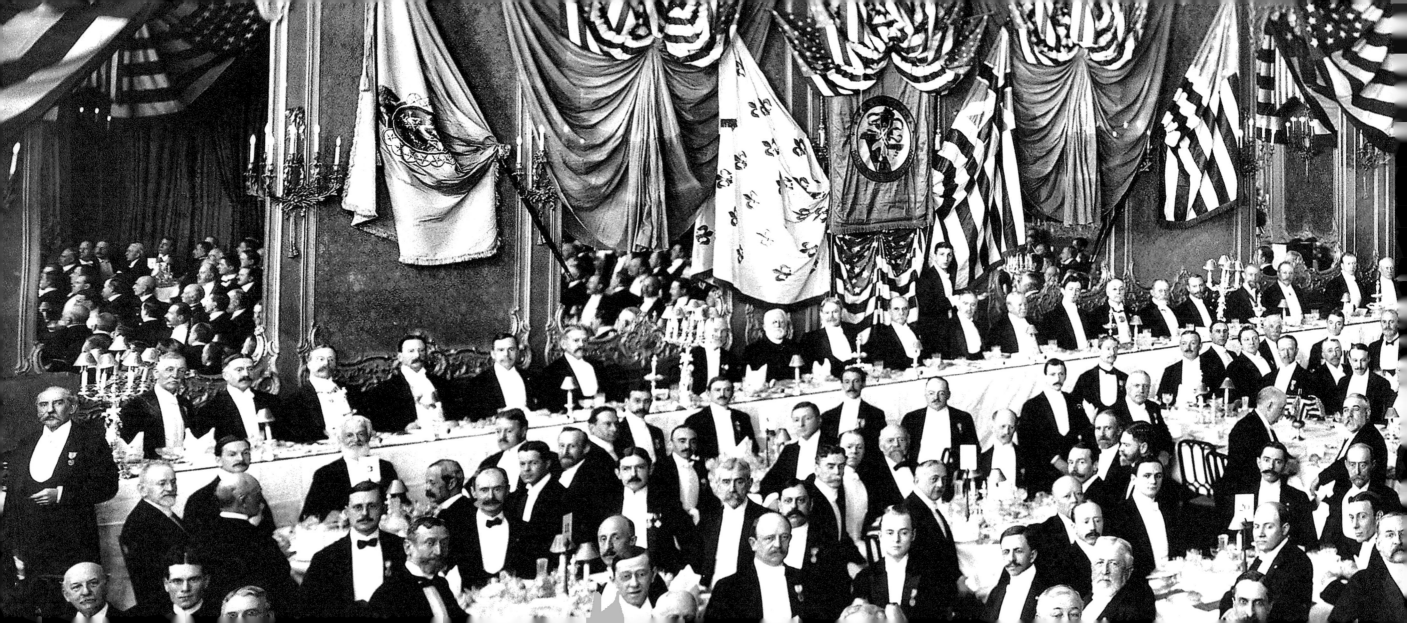

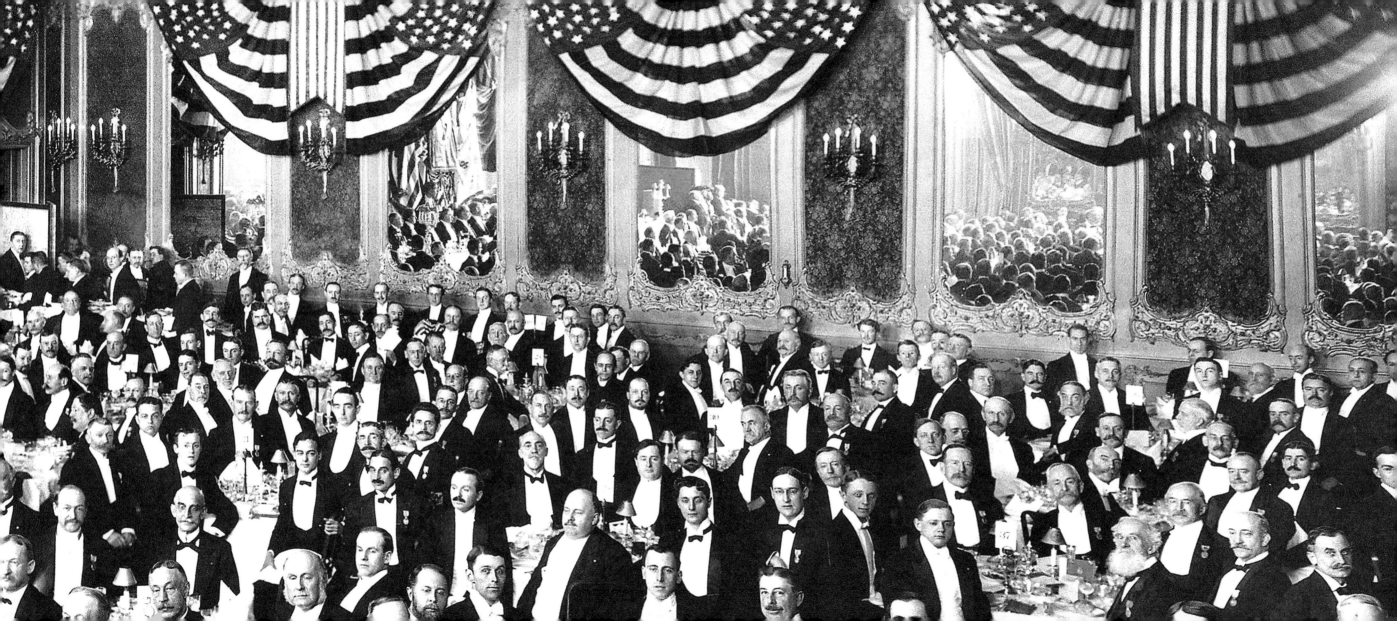

THE BIG

PICTURE

AMERICA IN PANORAMA

Josh Sapan

Introduction by Luc Sante

—

PRINCETON ARCHITECTURAL PRESS, NEW YORK

WITH TEXTS BY

JOSEPH ABBOUD p.39

DAN ABRAMS p.37

THE AMAZING KRESKIN p.108

YOGI BERRA p.131

DICK CAVETT p.87

DONNY DEUTSCH p.40

MARK HALPERIN p.72

CHRISTIE HEFNER p.62

ARIANNA HUFFINGTON p.38

RAYMOND KELLY p.42

BOB KERREY p.15

NORMAN LEAR p.110

JOHN LEWIS p.67

PETER NEUFELD p.68

BILL PERSKY p.104

ANNA QUINDLEN p.81

STEVE RATTNER p.120

ROGER STAUBACH p.137

HENRY STERN p.126

MARTHA STEWART p.64

LAWRENCE SUMMERS p.16

MAX TUCCI p.122

KATHLEEN TURNER p.59

KAY UNGER p.101

Contents

Foreword

Josh Sapan

started buying group panoramic photographs thirty-five years ago without much plan or thought. I wandered flea markets and antique stores and bought whatever was cheap, framed, and captured the rather solemn whimsy so many panoramics present. I ran out of space for them around the same time my wife ran out of patience, but I still couldn't resist the highly posed portraits that seem to reveal so little in their formality but so much in the eyes of the people in the pictures. Over time, I began to understand the odd window that the groups provided into the history of the United States.

By the time I had fifty displayed, they started to sketch anecdotal insight into America from the late nineteenth to the early twentieth century. Even in its random assembly, the collection captured many social and political threads that were defining the country, from the passion for cars evident at a 1915 convention of the Good Roads Association to the press for racial equality as expressed at the 1932 NAACP conference and the growing middle class's increasing opportunities for leisure activity, on display at early Miss America pageants. However disparate in tone, they share intent, a recognition of the value of the shared experience. At first look, these stiff pictures seem to defend against any insight into what the people are feeling. A closer look at their expressions often reveals much in the nuance: pride, determination, focus.

Twenty-four of the images have captions written by people whose notable accomplishments provide a personal connection to the subjects and an authoritative point of view. I am grateful for their words, which make the photos live in vivid context.

My teenage children are the most photographed generation in history: from birth videos to seemingly instantaneous updates on social media, their lives are published with astonishing speed. But they, too, pause at the panoramics, struck by the scope of the efforts, the value of a different kind of community. "We were here," the faces in the photos seem to say, "and it mattered."

Introduction

Luc Sante

The panoramic photograph is a strange and compelling medium, the widest of wide screens, a time-lapse that occurs in a single frame, an ostensibly faithful record that can blur the line between fact and fiction. Photographs may be meant, at least in theory, to replicate the function of human eyesight and transmit the contents of a given glimpse to other eyes at other times. The panorama, however, abandons any pretense of biological mimesis; its view, far beyond human capacity, is frankly that of a machine. Even allowing for peripheral vision, the 150-degree range of the very first panoramic camera extends beyond our field of sight—to say nothing of the 180 degrees of the Kodak Panoram (1899) or the 360 degrees of the Cirkut (1904).

The panoramic photograph was invented in the 1840s, more or less simultaneously by an Austrian, Joseph Puchberger, and a German, Friedrich von Martens. It owes its conceptual foundation to a line of European panorama painters beginning with the Irishman Robert Barker, who painted his first, a view of Edinburgh, in 1788, and continuing to Louis-Jacques-Mandé Daguerre, who went on to be one of the two or three people responsible for the invention of photography. The painted panorama was explicitly designed as a draw for audiences, a species of artistic showbiz and a tourist attraction in the earliest days of tourism. An enduring example is the full cylindrical panorama, or cyclorama, of the battlefield at Waterloo, the destination of the very first packaged tours.

Despite its European origins, the panoramic photograph has always seemed like an especially American form of expression, uniquely adapted to the scale of the wide-open country of the late nineteenth and early twentieth centuries and its corresponding optimism and ambition. A more pertinent predecessor in the United States might be the paintings of Frederic Edwin Church, especially his *Niagara* of 1857—distinguished from many contemporary depictions of the falls by what one critic termed its "aggressively horizontal proportions"—which

toured the nation and the European capitals, attracting long lines of viewers everywhere. Even so, the earliest panoramic photos made in the United States were primarily cityscapes, which were employed by boosters to sell prospective developers on the unclaimed potential of their subjects—Duluth, Nome, San Francisco—by displaying in a single frame both their attractively built-up centers and the unexploited acreage beyond.

The format fully came into its own in the early twentieth century. While earlier models had depended on a succession of individual plates, as well as very expensive handcrafted cameras, the introduction first of flexible film, in 1888, and then of the first manufactured panoramic camera, the Al-Vista, in 1898, completely altered matters. The idea was in the wind. Within a few years Kodak had introduced its Panoram, Sears-Roebuck its Conley, and smaller concerns such models as the Wonder Panoramic and of course the Cirkut, the apogee of the format, first produced by the Rochester Panoramic Camera Company and later by the Folmer & Schwing subsidiary of Kodak. The Cirkut took large-format film—five to sixteen inches high, depending on the model, and as much as twenty feet long (the most popular length was around thirty-six inches, hence the expression "yard-long photo")—and both the film and the camera rotated, on a specially designed tripod, a full 360 degrees.

A lateral development was the so-called banquet camera, which Folmer & Schwing began making at some undetermined point in the 1890s. A plate camera that featured rack-and-pinion focus via a gear track on a base rail, with an 18" to 22" bellows draw, it produced 7" x 17", 8" x 20", or 12" x 20" prints in which every detail near or far was in equal focus—an obvious boon in the era of large, showy gatherings in mammoth interior spaces.

The panoramic photo came of age, not at all coincidentally, in the same period that saw the rise (and fall) of the real-photo postcard. Indeed, these two media, which might at first glance appear distant or even opposed in purpose and ambition, turn out to be very closely related—both were applied to the task of cramming as much information as possible into the frame, a significant consideration for a time that saw both the dramatic expansion of vernacular photography and the proliferation of American business that expanded villages into towns and towns into cities. In some cases they were even made by the same people, as exemplified by the career of the great photographer of the western Adirondacks Henry M. Beach, of Remsen, New York. Beach employed the postcard format for a hundred purposes—portraits, architectural studies, records of local commerce, chronicles of disaster—and the panoramic for sweeping vistas (most frequently hotels and camps pictured with their attendant lakes and the mountains beyond)

and large groups (hunting and fishing clubs, for the most part, and after 1917 the military). Among his postcards are scenes that might have been better served by the panoramic format, but his panoramas could not have been better expressed in any other mode.

The panoramic camera was used to record nature scenes (the very rare vertical panoramics tend to fall into this category, such as top-to-bottom views of California redwoods), circus parades, processions of vehicles (from motorcycles to borax-laden mule teams), army encampments and artillery displays, aftermaths of particularly spectacular disasters (fires, floods, and train wrecks, mostly), town views (bird's-eye scenes as well as Main Street four-corners shots), and of course large gatherings of people, a category that may account for as much as 90 percent of the genre. All panoramic cameras rotate (except the banquet camera), which means that distortion is factored into the process. It's especially visible in ground-level town scenes, where the angles of the blocks protrude acutely, like so many wedges of cake. Natural landscapes are much harder to judge unless you actually know the place, whereas crowds represent anamorphic fibs—when you see a line of people, such as bathing beauties or circus performers, what you are actually seeing is a semicircular array. And because the exposure occurs in a horizontal sequence, a more or less significant lapse of time

separates one end of the picture from the other, a wrinkle exploited in moderately sized group shots by the inevitable joker who poses near the left margin and then runs around behind the camera to insert himself again on the right before the shot is completed.

The pictures in this book constitute a beautifully curated but nonetheless representative sampling of the medium. Large crowds predominate—unsurprisingly, since purchase of prints by as many of a picture's subjects as possible was the economic backbone of the phenomenon. For all that the medium might superficially be thought of as equalizing, evidence of an array of personal styles can be discerned. This is especially evident in group shots, since while just about anybody can throw a hundred bodies against a backdrop, spreading them out to fill the frame, it takes an experienced eye to work up a dialogue between the crowd and its setting. The portraitist of the Yale Varsity Crew (pages 134–35) managed to subtly indicate the river and the boathouse, assert the individuality of the team members (an uncommon accomplishment in the field of team photos), and arrange light and dark jerseys

in a pleasingly jagged rhythm, making the whole a bluntly modern, eternally fresh composition. Perhaps the most spectacular shot, however, is the one by Wagner documenting a stop in Shasta Springs, California, by New Yorkers en route to a convention in Seattle (page 17), which demonstrates the exceptional if usually neglected power of asymmetry in the panorama. The delegates are joined in their assembly by the engine of their train, which looms over them like a friendly pachyderm, while the rails swoop away to the right, into the mysterious forest of the West. The composition, a careful balance of shapes and tones, suggests adventure where many of the other pictures go for assertive stolidity.

Elsewhere, a ragged cluster of students appear to have wandered into a study of the buildings on the Phillips Exeter campus and are trying to make up their minds what to do about it (page 49). H. M. Flagler's party, detraining at Key West on the first rail trip there, is met by a vast, chaotic horde that fades out somewhere near the horizon, like a tribe hailing their king (pages 20–21). If the banquet-camera shot of the Sons of the Revolution at Delmonico's (pages 2–3) stands in for innumer-

able such pictures but manages to be more crisply rhythmic than most, then B. J. Falk's shot of the Casino grounds at Newport (page 127) employs rhythm to make an extremely unusual panoramic composition, sprinkling a pointedly sparse crowd—I count twenty-eight, with not a single face clearly visible—at irregular intervals, near and far, over the greensward and the tennis court. Falk was a theatrical photographer, and here he is effectively staging the season at Newport as an allegorical tableau.

And then there are a train wreck, a factory interior, an actors' strike on Broadway (wonderfully cast as a sea of straw boaters), a number of bathing-beauty lineups, an array of motor homes, a spectacle at Coney Island, a gushing oil well, and a fire department. There are feminist gatherings, the NAACP, the Anti-Saloon League, labor unions, a peace conference, a seminary, a widows' and orphans' home, a judges' shad bake, and a left-wing circus. It is difficult if not impossible to imagine any of these pictures as having been taken anywhere but the United States, whose riches and contradictions they embody so nobly and gracefully.

1
BUILDING AMERICA

America is a country that doesn't know where it's going but is determined to set a speed record getting there. —Laurence J. Peter

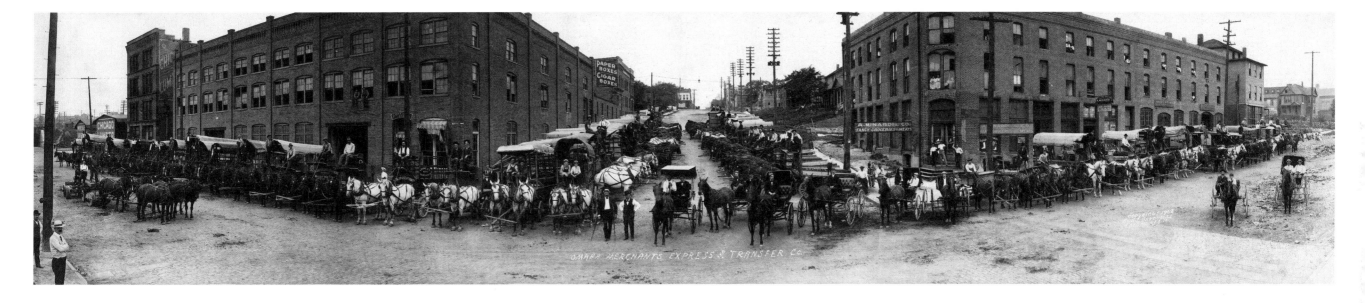

Historian Frederick Jackson Turner's "frontier thesis" advanced the idea that the United States' expansion westward brought with it a shedding of stale European concepts and produced a distinctly American set of ideals saluting egalitarianism, innovation, and rugged individualism. Turner considered the American frontier closed by 1893, after which expansionism evolved into internal development and, not rarely, exploitation. Descended from those early generations of egalitarian pioneers were a generation of successful entrepreneurs—a moneyed, privileged, and self-protecting cadre of business and civic leaders. Around the turn of the twentieth century, Walter S. Jardine, head of the Omaha Merchants Express and Transfer Company, helped organize—and remained a member of the inner circle of—the Omaha Business Men's Association, a secret organization of local business leaders who stalled the expanded unionization of labor in Omaha for the next three decades. As long as there's been Big Business in America, there's been organized labor, the contest between them ceaselessly moving through cycles that first favor one side, then the other, even up to this day. —**Bob Kerrey**

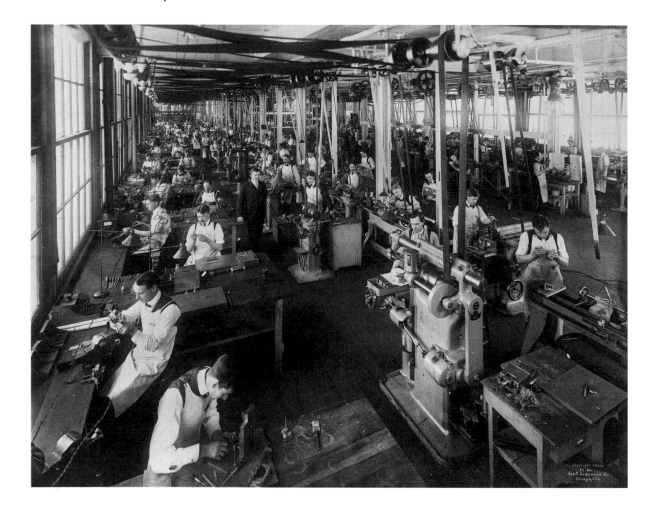

Even after John Birch and saloon keeper James Ritty devised the first cash register in 1883, many countermen still did the math of a bill in their heads or scrawled numbers down the side of a customer's goods-filled paper bag. In its first ten years of operation, the National Cash Register Company (NCR), founded by John Henry Patterson and a group of investors in 1884, sold only sixteen thousand registers. But the country was growing and maturing, becoming more industrial and businesslike. Toting up receipts in one's head wasn't going to do it anymore; by 1914, NCR was putting out 110,000 registers annually. As the country evolved technologically, so did NCR, turning out the first electric register in 1906 and its first computers in the 1950s and entering the twenty-first century as a global supplier of scanners, ATM machines, self-checkout machines, and more.

Patterson was a paradox. He was (for the time) a notably compassionate employer, providing indoor bathrooms, on-grounds medical attention, and refreshing ventilation for his workers, as well as coffee and hot lunch for his female employees. At the same time, he was just as notably aggressive in his business, locking up 95 percent of the cash register market by 1911, though that resulted in his and several other NCR officers' convictions on violations of the Sherman Antitrust Act.

—Lawrence Summers

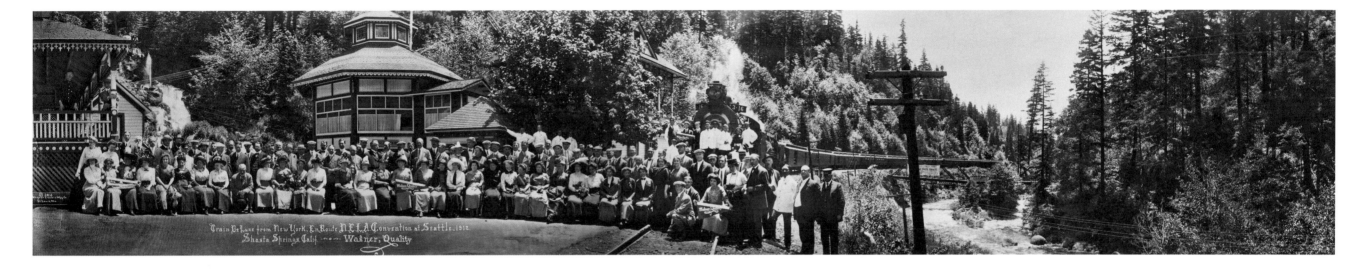

Train De Luxe from New York, En Route N.E.L.A. Convention at Seattle, 1912.
Shasta Springs Calif. Wagner, Quality

This photograph depicts a century-old analogue to present-day airplanes bringing tens of thousands of people to Las Vegas for a National Association of Broadcasters convention or International Consumer Electronics Show. One hundred years ago Mayor George Cotterill of Seattle, Washington, welcomed the attendees of the thirty-fifth National Electric Light Association convention to his city. Electric lighting was quite new at the time. The mayor was a booster for his city, which had tripled in population between 1900 and 1910 (from 80,000 to 240,000 residents), and said that the city of Seattle may have been "the best lighted city in America, and, I think it might be added, in the world." He cited statistics to prove his point: eight hundred street lamps lit Seattle's sister city, Los Angeles; sixteen hundred illuminated Seattle. Cotterill told attendees that, in the slang of the day, "It's good to live in an age when so much is doing."[1]

Until the 1920s if you wanted to get milk out of a cow, you pulled up a stool, set a bucket under its udder, reached under, and squeezed. A skilled milker could work his way through twenty cows in a single ninety-minute milking session. The idea of automating this process had been a dairy farmer's dream for decades, and throughout the late nineteenth century, a number of automatic milking devices were designed. By the end of the century, more than one hundred patents had been issued for milking machines, but for one reason or another—such as maintenance issues or a lack of reliability—none had taken hold at a large scale. Even into the twentieth century, as electric lights were replacing kerosene lanterns and as the combustion engine displaced the horse, it was likely that the milk you poured from a bottle (milk bottles had been introduced in 1884) had been squeezed out by hand. By the 1920s, however, as dairy farms grew larger to meet the demands of a growing population, the stool and bucket went the way of the horse-drawn carriage, and large-scale cow milking became a mechanical, production-line affair.

In the current era of interstate, international, and intercontinental transport and commerce, a United States that was at one time a patchwork of regional transportation systems seems quaint. But that was exactly the case during the early days of railroading. Beginning in the late 1820s, railroads in the United States were built under state-granted charters, generally to supplement an established regional canal system. Early railroads linked key parts of a state, then usually expanded to link hubs within a particular region. The country would not see its first transcontinental railroad until the Central Pacific and Union Pacific lines famously linked at Promontory Summit, Utah, in 1869. (Even then, gaps remained for several years.)

The Cincinnati, Hamilton & Dayton (CH&D) Railroad was a typical early railroad. Founded in 1824 by John Alexander Collins, an English immigrant and one-time locomotive engineer, the CH&D line originally covered only 59 miles of track. Even at its peak in 1902, the line consisted of only 640 miles, all within Ohio. Rail lines expanded as smaller lines were absorbed by larger ones, as was the case with the CH&D, which was acquired by the Baltimore & Ohio Railroad in 1917.

Mr. Henry M. Flagler and party exiting the first train to arrive in Key West, at the opening of the Florida East Coast Railroad — *Key West, Florida, ca. 1912*

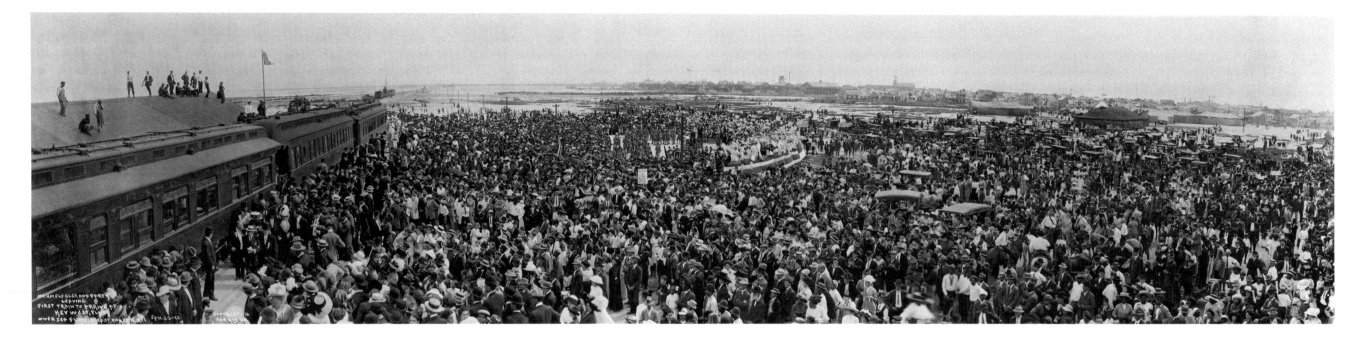

Henry M. Flagler, one of the founders of what came to be Standard Oil, is considered to be the man who invented modern Florida. A visit to the state in the 1870s sparked a vision in his entrepreneurial eye. A man who saw what could be rather than what was, Flagler left the oil business in 1885 and set out to realize his dream for Florida at an age when most men would have retired. Flagler's dream was to unite the state through modern transportation, which at that time meant by rail. He acquired several small railroads and joined them to form the Florida East Coast Railroad (FEC), extending the system's reach— in one of the most impressive feats of American railroad construction—to Key West in 1912, thus tying the east coast of Florida together from Jacksonville to Key West. Wherever the FEC went, hotels and farms sprang up alongside. The FEC eventually went bankrupt during the Great Depression, but by then its rails had already laid the groundwork for decades of expanding tourism and agricultural development, which remain keystones in the state's economy.

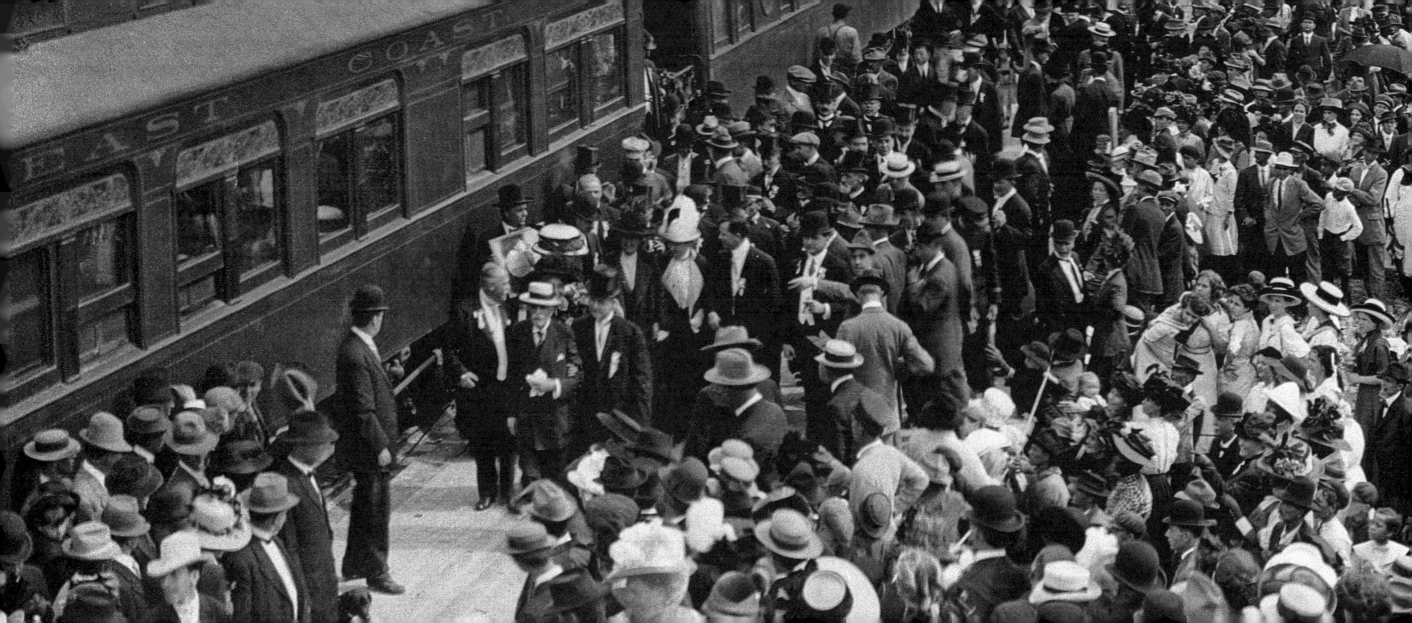

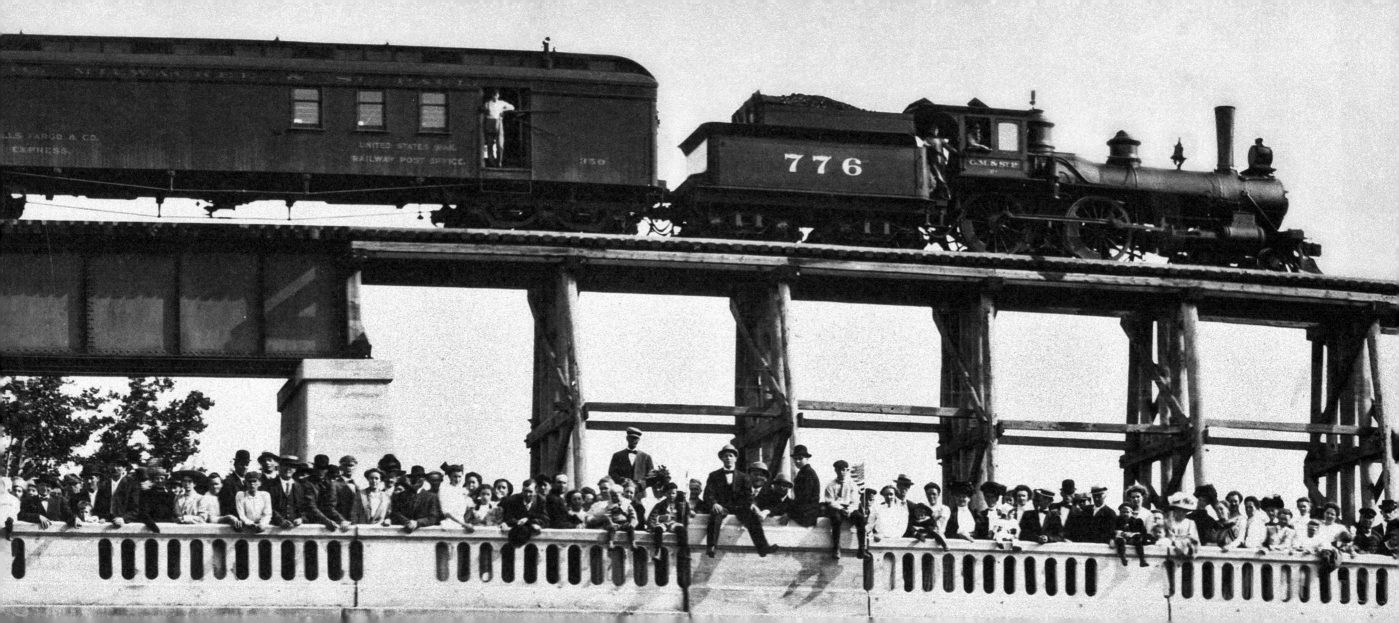

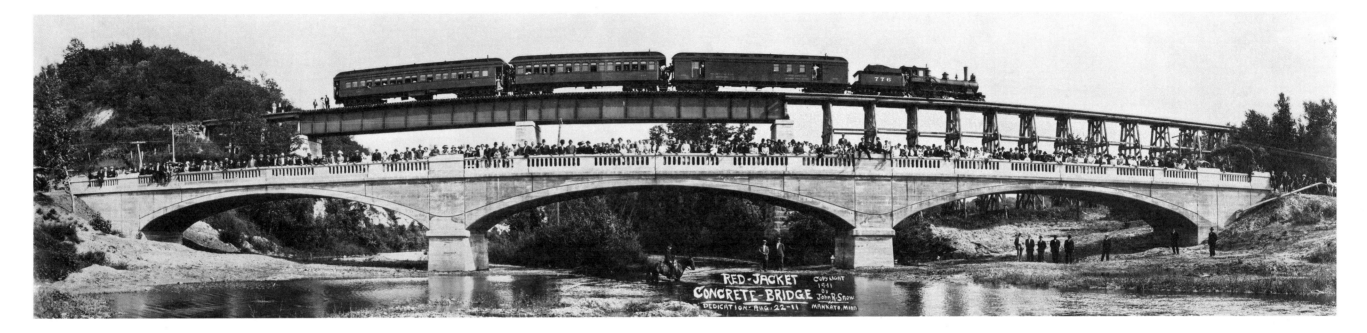

In many ways the story of the Red Jacket trestle bridge encapsulates the 150-year narrative of railroading in the United States, from its inception to its demise as a commercial enterprise to its role as a subject of preservation and reuse.

The bridge was constructed in 1874, but the effort to build it had begun in 1857. A series of political and financial challenges, including the effort of coordinating with other railroads and the financial panic of 1873, stalled the original plans. It was the Central Railroad of Minnesota that built the bridge, before that company was acquired by the Minnesota Valley Railroad in 1879. Minnesota Valley was sold to Milwaukee Road, which operated the line for almost a hundred years until its abandonment in 1978.

The railway and bridge were converted to a bike trail in 1992. (Many railroad rights-of-way have become parts of "rails to trails" reuse initiatives that have made beautiful old railroad routes into trails for bike riding and walking.) The trestle bridge, named after the local Native American chief Red Jacket, passes over the beautiful Le Sueur River in picturesque Blue Earth County.

Sadly, the trestle was damaged several years ago in a flood. Part of the bridge is being dismantled and stored with plans to build anew. While some preservationists consider anything new for the bridge to be a violation of its history, others cheer the effort to restore it.

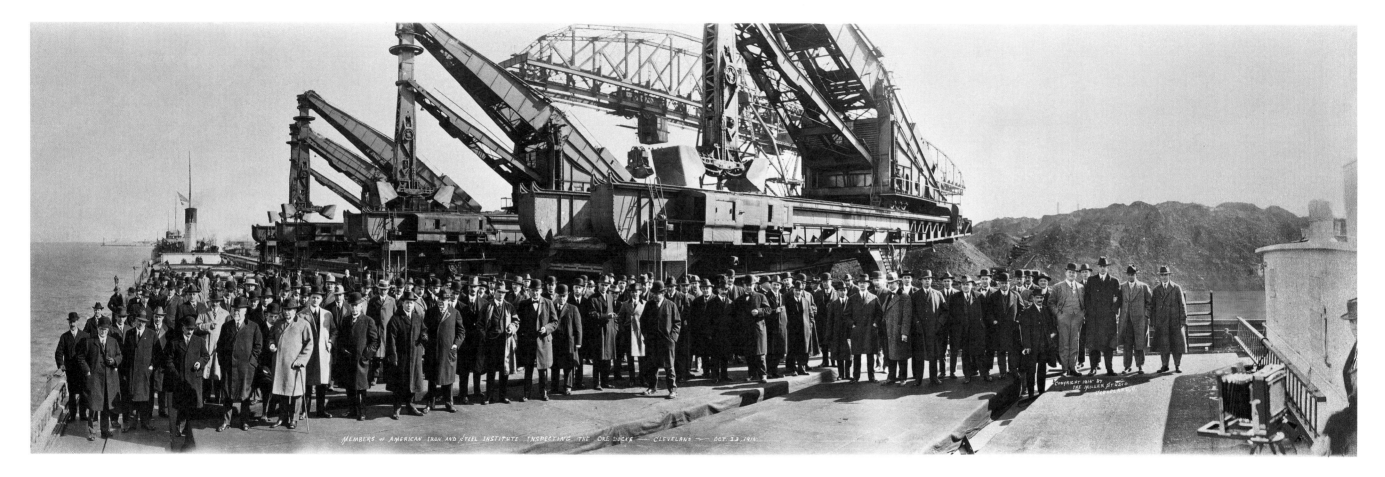

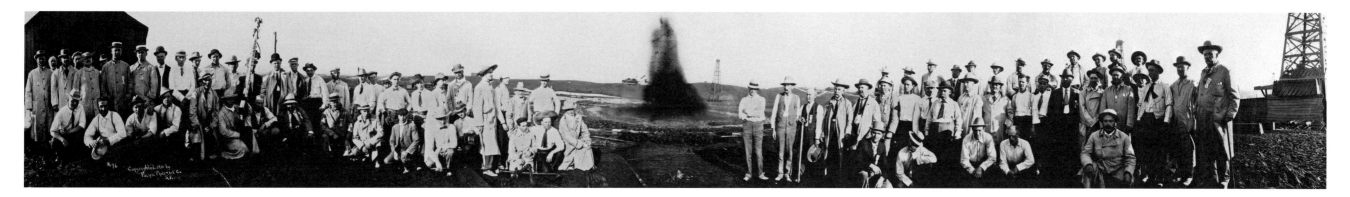

OPPOSITE

The American Iron and Steel Institute, one of the oldest trade associations in the United States, was formed in 1908. The organization had its roots in the American Iron Association, which had been set up in 1855 to promote iron-trade interests. As the country grew, so did the need for iron and steel. Steel, in particular, tied the country together, playing an essential role in its development: it was crucial to the advancement of railroads, it fueled the automobile industry, and it was later used to shape the skeletons of the high-rise buildings erected throughout the nation's expanding cities.

By 1900 the United States was the world's largest manufacturer of steel, and by the 1920s the country was supplying 40 percent of the globe's iron and steel. The production peaks for the American steel industry were the two world wars; after World War II the steel market became saturated and was increasingly open to lower-cost foreign competitors. The 1970s severely punished an already retreating steel industry, with an oil crisis followed by a lingering recession. Steel mills, once a cornerstone of Midwestern economy, disappeared, and what had once been called the Steel Belt was renamed the Rust Belt.

ABOVE

The "gusher"—the explosive birth of a new, rich oil well—was a symbol of American prosperity at the beginning of the twentieth century. Long before the automobile, a big-money oil industry existed in the United States: modern oil drilling is said to have begun in Pennsylvania and West Virginia to meet the need for lighting (when whale oil became too expensive) and later to fuel machinery during the industrial revolution.

California's San Joaquin Valley had already seen several notable gushers, but nothing like Lakeview #1, which erupted so violently one day in 1910 that it blew the crown off its derrick. It was, at the time, the most famous gusher in the United States and continued to spout a torrent of black gold for eighteen months. The ironically nicknamed Dry Hole Charlie Woods, the driller who brought the well in, said that Lakeview #1's drill "must have cut an artery."[2] Gushers, while common, were both wasteful (it is estimated that half of Lakeview's oil was lost to evaporation and runoff) and dangerous. New technology introduced in the 1920s eliminated gushers and, perhaps, some of the romance of the heady early days of the oil industry.

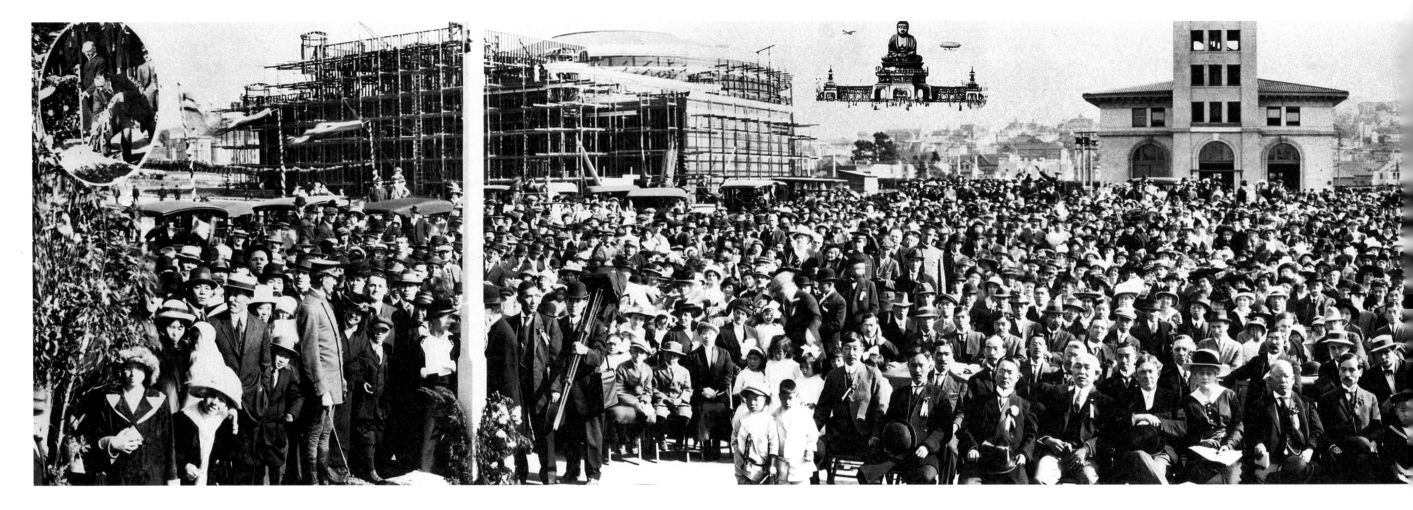

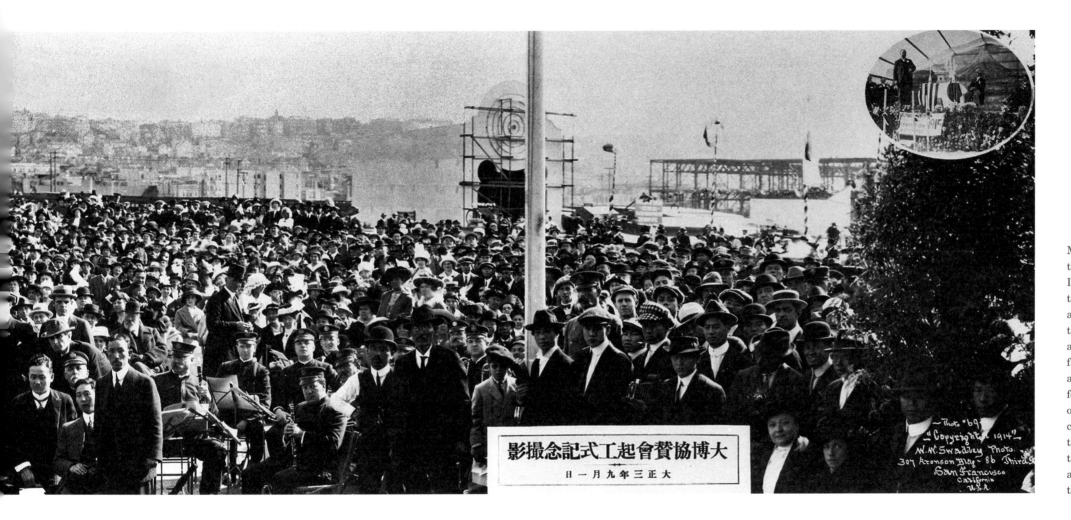

大博協賛會起工式記念撮影

大正三年九月一日

~Photo "69"
"Copyright 1914"
N. W. Swadley Photo.
307 Aronson Bldg ~ 86 Third S
San Francisco
California
U.S.A.

Many world's fairs followed the first one, the 1851 Great Exhibition of the Works of Industry of All Nations in London. Each fair tried to outdo the previous one, but all were built around the idea of bringing together state-of-the-art advances in science and technology from around the world. The San Francisco world's fair of 1915 was no exception, conceived in part as a celebration of one of the great engineering feats of the still-new century, the completion of the Panama Canal. The fair also saluted the city, which had come back remarkably from the devastating earthquake of 1906. Eventually, the focus of the world's fairs would change, and they became less about celebrating innovation than about showcasing the host country.

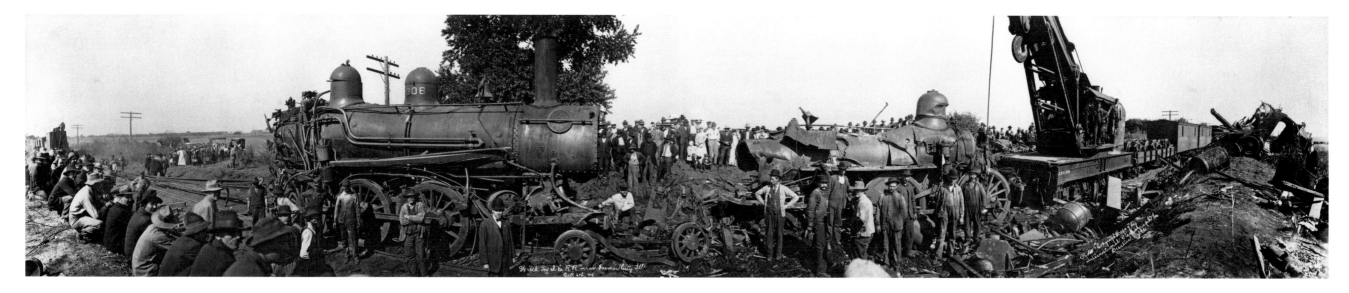

Morbid fascination with disaster is not a product of modern-day media but has been a long-standing public preoccupation. Before multicar highway pileups and plane crashes, there were train wrecks, and the very first whiff of a rail disaster was quick to draw photographers. This image shows a train added to the schedule to service the state fair in Springfield in a head-on collision with a regularly scheduled southbound train from Chicago.

The Illinois Central Railroad (chartered in 1851 and still in business today) was already famous for an earlier tragedy: a 1900 wreck near Vaughan, Mississippi, during which one of the engineers— John Luther "Casey" Jones, the only fatality— remained at the throttle until the end to save his passengers. "The Ballad of Casey Jones," penned by a black engine wiper named Wallace Sanders, is still a folk favorite today.

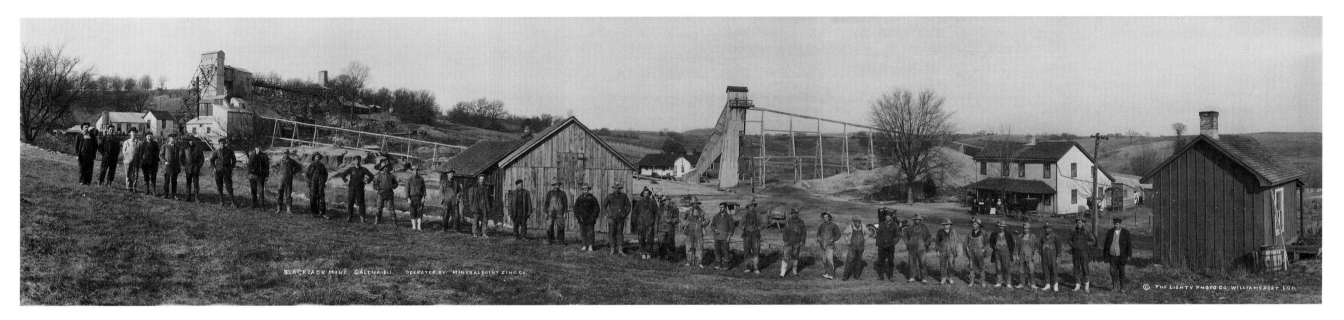

Even the town's name, Galena, originates from the mined substance that brought it into being. The place, first settled in 1818, was still nameless in 1822 when Colonel James Johnson received a lease from the federal government to mine in the area. He found rich deposits of lead and by the following year had turned out 425,000 pounds of ore. Six years later, output had swelled to thirteen million pounds, and by 1845 the lead mines of Galena were producing 80 percent of all lead used in the United States and also producing zinc.

As the lead industry exploded, so did this little community on the Fever River (later renamed the Galena River), which filled with miners and gamblers, traders and trappers, and river men. Deciding it was time to formally christen their town, the townspeople chose to name it after galena, a lead sulfide. By the 1840s Galena was the richest town in Illinois.

The mine began to peter out beginning in 1849. The Galena River became choked with silt (a result of erosion from the clear-cutting done by the mining operation), and the town's fortunes began to falter. The mine closed in the early 1880s but was reopened in the early 1900s for zinc extraction. When the mine closed permanently and residents began leaving, the city lacked the funds to demolish the abandoned buildings. Those buildings— today refurbished and restored—position Galena as "the town that time forgot,"[3] with 85 percent of the town's architecture preserved as a historic district.

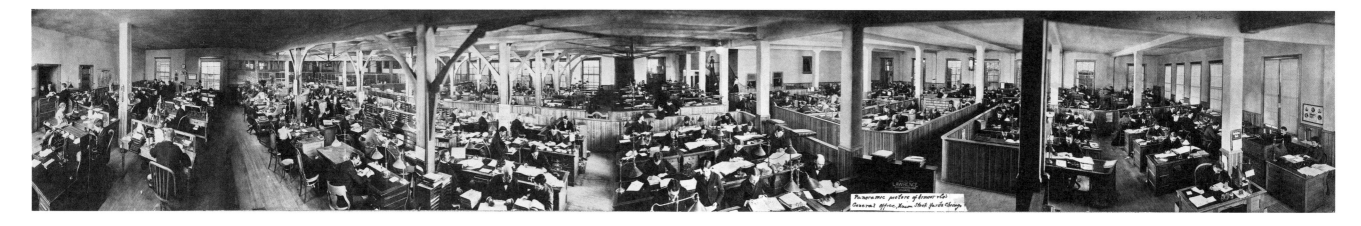

Generations of Americans grew up humming the Armour hot dog jingle, which was first introduced on radio: "Hot dogs, Armour hot dogs…the dogs kids love to bite."

Even before the jingle debuted, the Armour name had been long established in the food marketplace. The company was founded in Milwaukee, Wisconsin, in 1867 by the Armour brothers and relocated to Chicago in 1875. Within a few years of moving, it become one of the country's largest businesses and the heart of the American

meatpacking industry. The company left no part of its animal source material unused (it was said that Armour used "every part of a pig but the squeal") in turning out everything from food products to fertilizer. Infamously known as a low payer and strike breaker, Armour was persistently dogged by labor troubles. Its exploitative and unhygienic practices were detailed, along with conditions throughout the then-unpoliced meatpacking industry, in muckraker Upton Sinclair's novel of outrage *The Jungle* (1906).

The Armour family sold most of its interest in the early 1920s. The company would pass through several owners thereafter, including the Greyhound bus corporation. Although Armour closed its Chicago operations in 1959, the Armour-Star brand name remains one of the most familiar at meat counters, and, come barbecue season, radio and TV ads still pose the question: What kind of kids eat Armour hot dogs?

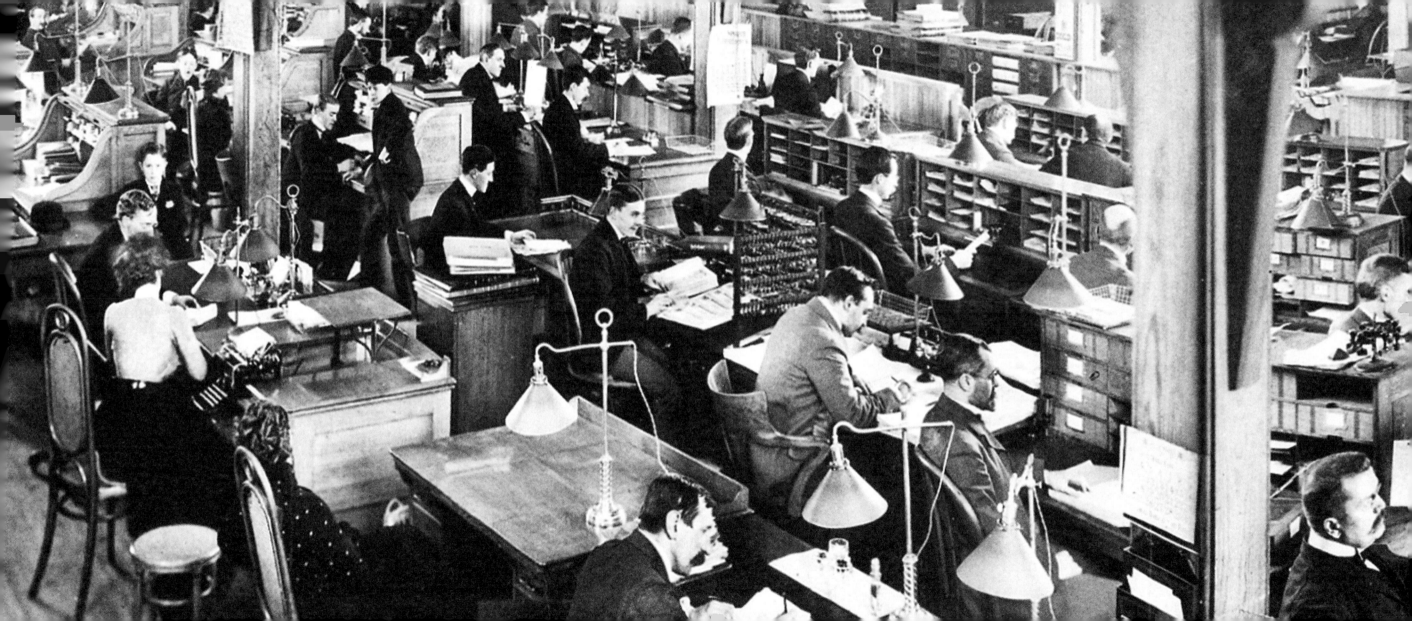

In 1900 more than 60 percent of the population still lived in the agrarian parts of the United States, the horse was the primary mode of transportation, and most people did not finish school. But it was clear the country was growing—and growing up. The great urban centers of both culture and commerce were expanding as more people were employed in the ever-increasing number of factories in burgeoning industrial centers. By 1920 more than half of the American population resided in cities.

Even early on some critics noted that for all the material and financial gains that accompanied urbanization and industrialization, something was being lost in the process. Sinclair's *The Jungle* exposed the heartless core of industrial meatpacking; Booth Tarkington's Growth trilogy of novels included the Pulitzer Prize–winning *The Magnificent Ambersons* (1918), which rendered an elegiac portrait of Victorian elegance fading as the asphalt tendrils of the city crept out to the suburbs; King Vidor's 1928 film *The Crowd* depicted an idealistic young couple whose spirit and dreams are crushed by the monumental indifference of the Big City. Three decades later, playwrights Jerome Lawrence and Robert Edwin Lee caught that sense of early twentieth century unease in their 1955 play *Inherit the Wind,* inspired by the 1925 Scopes Monkey Trial: "Progress has never been a bargain," proclaims the play's main character, Henry Drummond, based on celebrated attorney Clarence Darrow. "You have to pay for it."

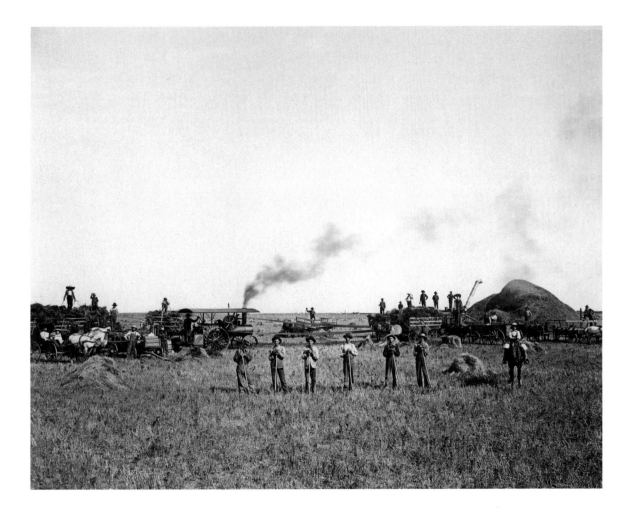

There was a time when the word *horsepower* literally meant the power provided by a horse. By the 1860s most machinery on American farms was powered by horses. California wheat farmers, for example, used a combine (a machine performing the functions of a reaper, thresher, and blower), which was pulled through the fields by as many as twenty horses. Although the first steam-powered traction engines (later simply called tractors) appeared in 1858, draft horses remained the prime engine for hard labor on most farms. As the century came to a close, the first tractors powered by internal combustion engines were introduced. They did not become widely popular until around 1910, by which time they had become both smaller and cheaper.

This was not, however, the end of the horse. Draft horses—more reliable than most automobiles—still hauled wagons filled with crops and transported farmers and their goods across unpaved roads. In 1915 the horse population in the United States reached its peak at twenty-one million (almost one for every five Americans). But during the following years, the gas engine gained and the horse lost. Many farms and well-to-do families kept their horses but as a luxury, not a necessity. Engines became smaller, more powerful, and more affordable; work that once required the power of twenty horses could now be completed by a single engine. Black ribbons of pavement extended out from cities and over rutted dirt roads, and the family carriage was replaced by the family car. And horsepower replaced horse power.

By the late nineteenth century, the seven Fisher brothers had found success building horse-drawn carriages at their shop in Ohio. But they saw a more lucrative future in the growing popularity of the newfangled "horseless carriages" and moved to Detroit, which by the early twentieth century had already become the center of automobile manufacturing in the United States. In 1908 they began producing car bodies for a number of carmakers, including Ford, Cadillac, and Studebaker, and were a success almost from the start.

By 1914, with their customer list constantly expanding, Fisher Body had become the world's largest maker of car bodies. In 1919 General Motors (GM)—itself a growing conglomeration of once-independent companies that had been customers of Fisher Body—bought a 60 percent interest in Fisher Body and by 1926 transformed the company into a completely in-house operation that provided bodies for all of its models, from limousines to trucks. GM vehicles came off the line with a plate that bragged "Body by Fisher." Fisher Body not only became synonymous with

quality car making but also were as well known for innovations that became industry standards, such as slanted windshields and dual wipers. At its peak, Fisher Body employed one hundred thousand people in forty plants. But as the fortunes of the American car industry sagged, so did those of Fisher. By the 1970s quality automotive engineering was increasingly associated with imports, and by the 1990s Fisher's operations had been absorbed into other GM divisions. The name Fisher Body had disappeared, and no longer did GM vehicles boast "Body by Fisher."

WORK

Every great man of business has got somewhere a touch of the idealist in him. —Woodrow Wilson

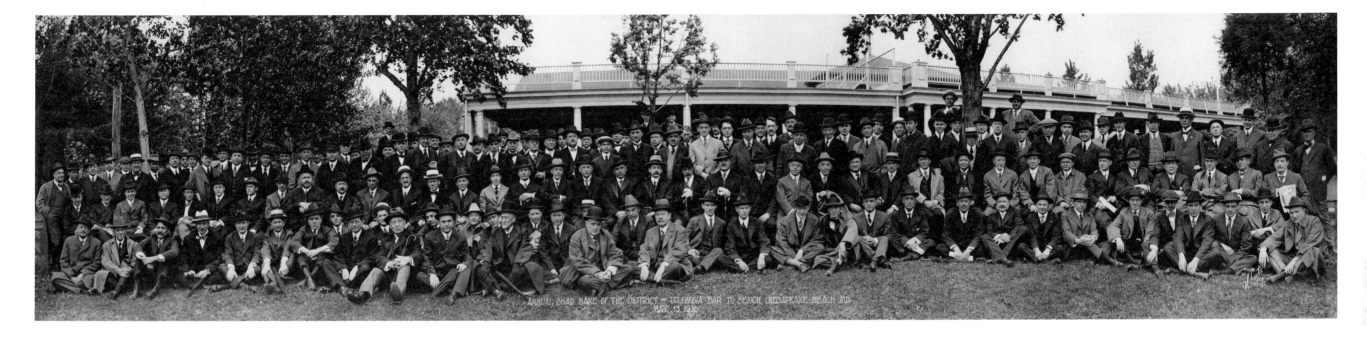

For much of the nation's history, judges have held a position—unusual in a democracy—of majesty in the public eye. Sitting at the bench, above and removed from the fray in the well of the court, draped in severe black robes, they were seen as examples of reserve and decorum, sources of sagacity and understanding: the ultimate arbiters of justice. Even here, at a presumably relaxed gathering of Washington, DC–area judges, each is dressed in jacket and tie and topped off with a gentleman's proper headgear.

That sense of unflagging dignity defined the popular image of judges until the latter part of the twentieth century, when TV cameras were granted increased access to courtroom proceedings. Court TV—which parlayed the inherent drama of the trial process to cable success—launched in 1991 and was transmitted to seventy million homes by 2003; the same year, all fifty states were on board for some kind of courtroom TV coverage. As judges were backgrounded in depth (often during live coverage), their every move and decision subject to the same analysis faced by pro athletes, some of their mystery—and majesty—seemed to wane.

—Dan Abrams

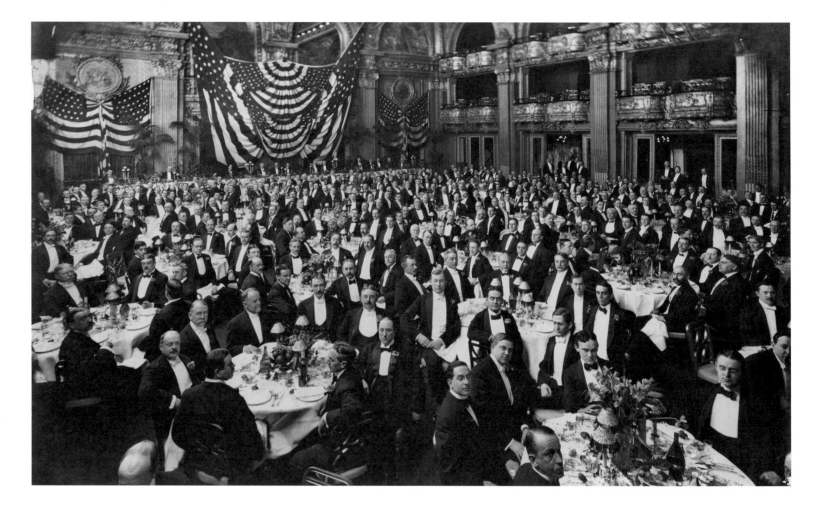

In our fast-paced, hyperconnected world, where politicians vie for votes on Twitter and a smartphone photo can spark a revolution, it can be easy to overlook the dominance that print news maintained in the United States for much of our country's history. The first newspaper printed in America was *Publick Occurrences Both Forreign and Domestick* in 1690— it lasted one issue. In 1775 there were thirty-one newspapers being published in the thirteen colonies; sixty years later, the number was twelve hundred. By the beginning of the twentieth century, the world of print resembled today's online news landscape in its sheer breadth, variety, and diversity of voices, including the now-iconic "yellow journalists" and the "muckrakers" who exposed society's ills. The coming of electronic media—first radio, then TV, cable, and the Internet—changed the way we consume news, ushering in an era of unprecedented participation and engagement. Today, more than three hundred years after *Publick Occurrences* hit the newsstands, we look forward to a hybrid future, with traditional outlets adopting the ideals of digital journalism, including speed, transparency, and engagement, and new media adopting the best practices of traditional journalism, with its emphasis on fact-checking, fairness, and accuracy. **—Arianna Huffington**

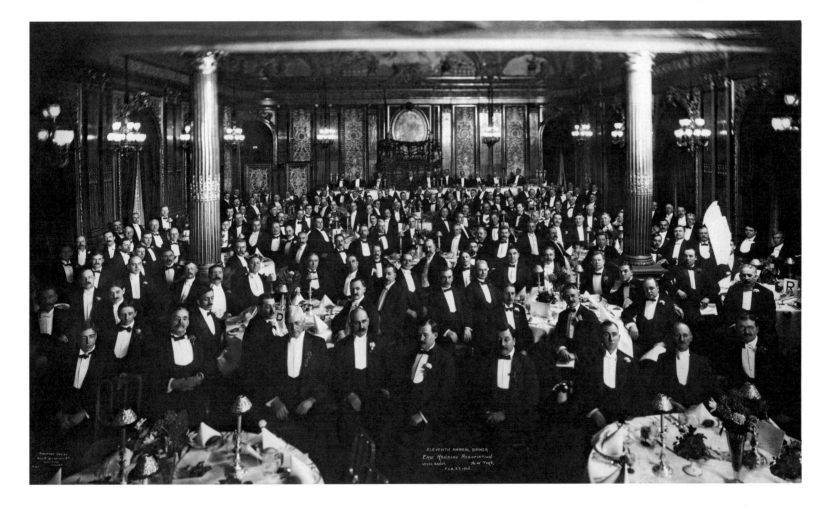

The great irony behind the devising of that acme of formal attire, the tuxedo, is that it was apparently created as an informal alternative to the traditional dinner garb of the late 1800s. There are several stories as to how the tuxedo came to be, although they all seem to intersect at Pierre Lorillard, a tobacco magnate who lived in Tuxedo Park, New York (Tuxedo apparently being a distortion of the Algonquin Indians' tribal name for the area). Usual dinner party wear of the day consisted of a long tailcoat and white tie, but the tuxedo—supposedly inspired by a Savile Row–designed dinner jacket for the Prince of Wales—was a daringly more comfortable, short-tailed design supposedly popularized by Lorillard's son Griswold and his equally well-positioned friends. Whatever the details, by the late 1880s the tuxedo (along with its name) had established itself as the go-to uniform for the most formal occasions and, at events such as the Erie Railroad Association's annual dinner, just as much a signal of social standing, success, wealth, and power. **—Joseph Abboud**

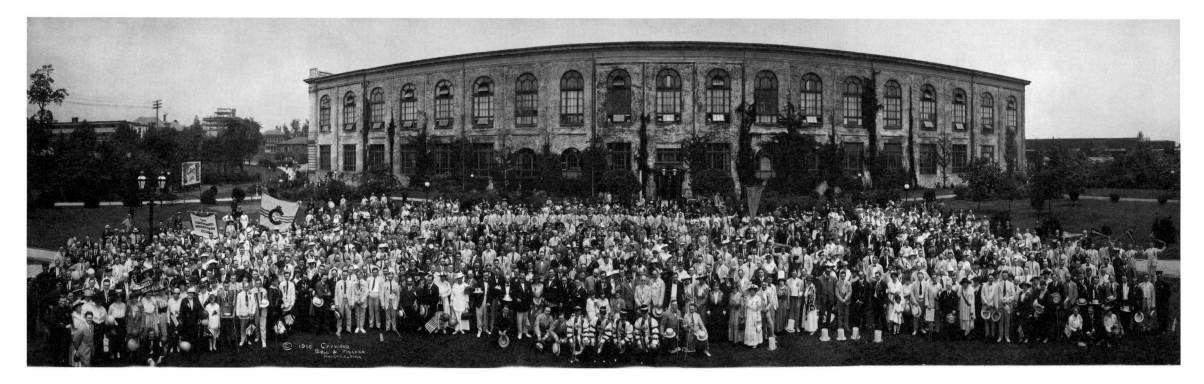

In proclaiming "Advertising Week," Mayor Thomas Smith of Philadelphia called this twelfth annual convention of the Associated Advertising Clubs of the World "one of the largest and most important gatherings of business men ever assembled."[4] One of the major goals of the convention was to prove advertising worked by providing merchants with an accounting system tying increased sales to advertising—in effect, one of the first audience ratings systems. The view of advertising at the time was significantly different from the image of hucksterism, hype, and spin that would follow World War II and the ad blitzes that went with modern media. According to the *New York Times,* the main message of the convention was that of "honest, intelligent, commercial publicity."[5]

—Donny Deutsch

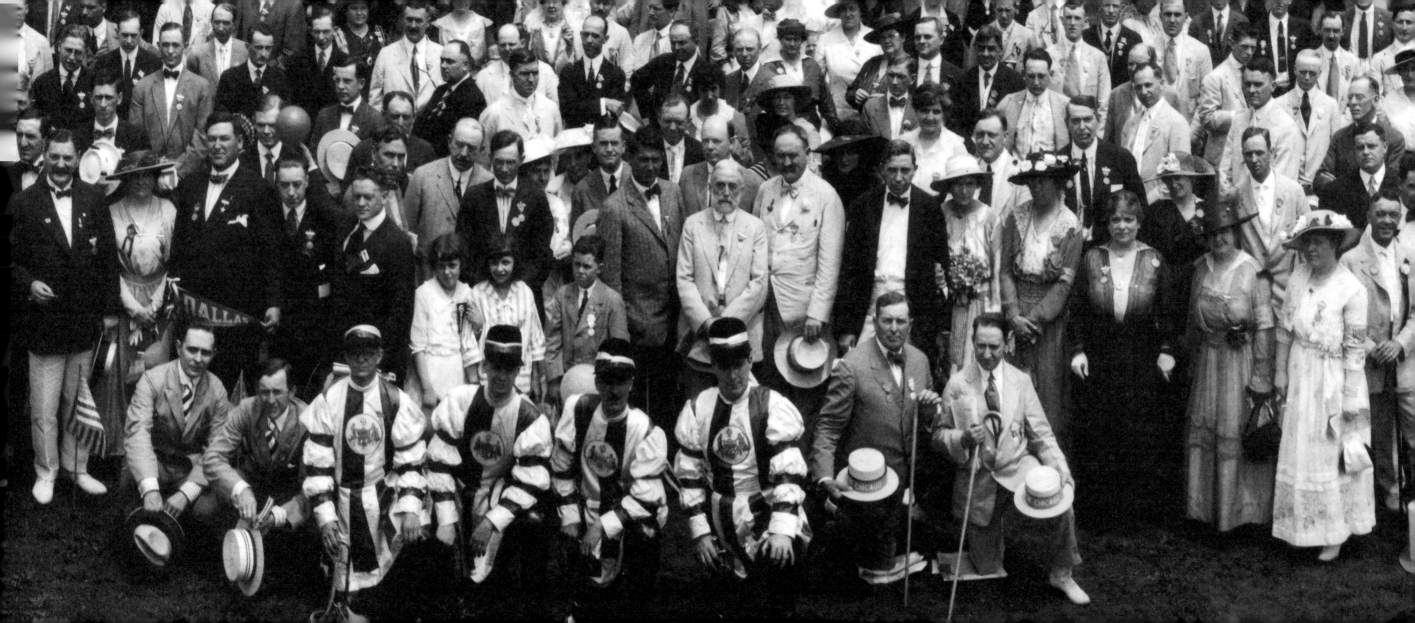

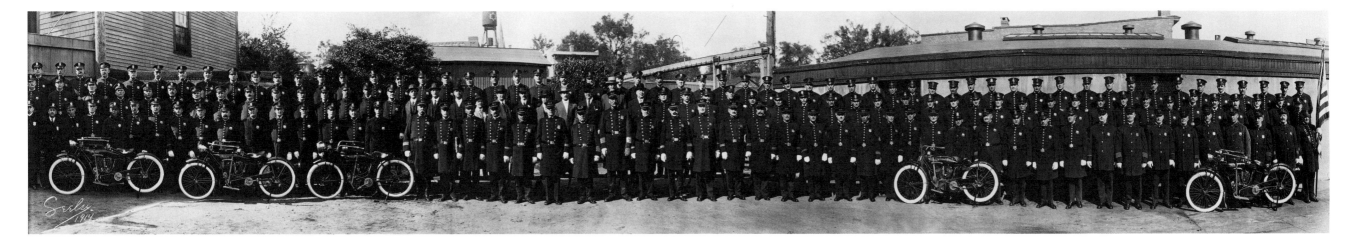

ABOVE
Down through the ages, society has relied
on the long thin line of police to keep it safe.
—Raymond W. Kelly

OPPOSITE ⟶
The National Recovery Administration (NRA)
was one of the signature accomplishments
of Franklin Roosevelt's New Deal. Created
in 1933, the objective of the NRA was to balance
the needs of business and those of labor with
the aim of creating a more stable and benign
business environment (in contrast to the
anything-goes dynamic viewed as contributing
to the economic crash of 1929).

The Supreme Court declared the NRA
unconstitutional in 1935. While the NRA's labor
reforms would have a long-lasting effect, the
corporate behaviors it was intended to moderate
have regularly resurfaced (as evidenced in the
savings and loan crisis of the 1980s, the bursting
of the 1990s dot-com bubble, and the financial
meltdown of 2007).

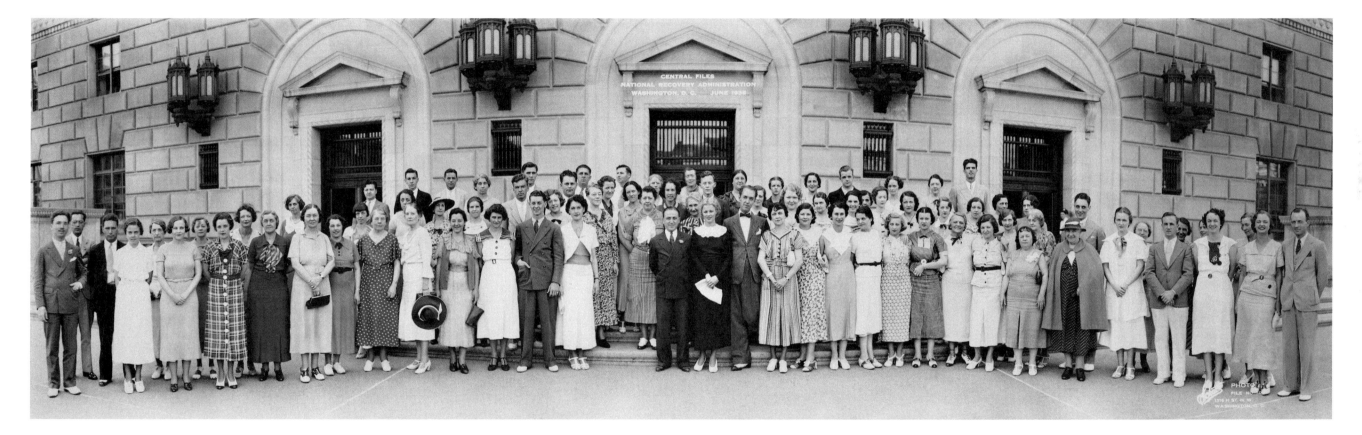

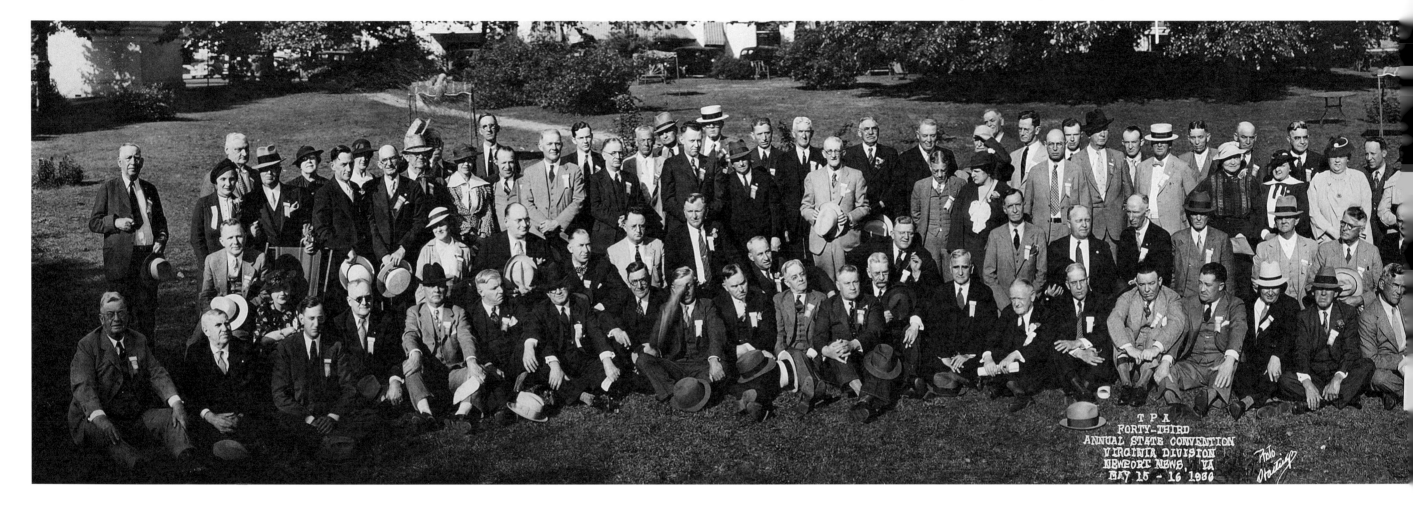

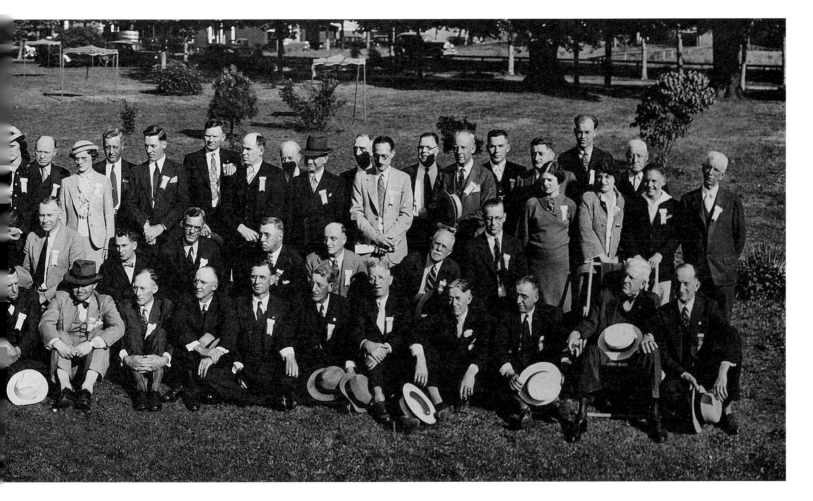

Traveling peddlers existed in the United States from its colonial beginnings. By the end of the nineteenth century, the quaint image of a lone, rambling seller with a wagon full of wares was replaced by a more energetic and sophisticated figure. The grand—and growing—scale of American manufacturing was unique even among the highly industrialized countries of the time, and required armies of well-trained salesmen to move goods. These men traveled along planned routes and exercised carefully thought-out sales strategies. The increasing tactical and strategic importance of sales personnel is evidenced by the fact that in 1917 a full 25 percent of the executive officers at the top two hundred American firms had been—at least at one time—salesmen.

In January of 1882 a small group of traveling salesmen met to share stories about the hardships of life on the road. That collegial meeting ultimately produced the Traveling Men's Club, which, in turn, became the Travelers Protective Association of the United States. With strength in numbers, members were able to negotiate more favorable terms from hotels and transportation companies. Later, the association's agenda expanded to providing benefits to members (such as insurance and scholarships for their children) and also involved itself in altruistic efforts (such as child-safety education programs in conjunction with local parent-teacher associations and police and fire departments)—activities it continues to this day.

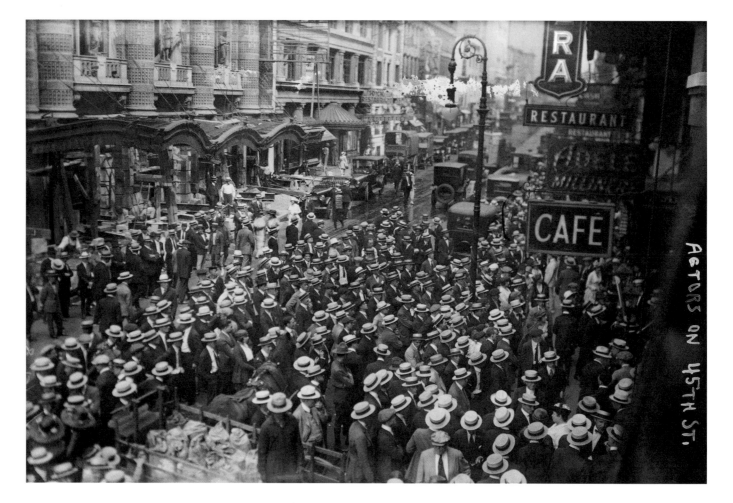

The labor union Actors' Equity was formed by a handful of performers in 1913, but theater producers of the day refused to recognize it. Tensions between actors and theater management and producers—who formed the Producing Managers' Association (PMA)—came to a head in 1919, when the still-unrecognized union called for what would be the longest strike (thirty days) in Broadway history. The month-long strike was ended when the PMA recognized Actors' Equity, which became a part of the American Federation of Labor.

Millions in box office revenue were lost during the month-long strike, as the dark stages inadvertently provided a boon for a relatively new form of diversion: the cinema. With no plays to see, patrons began exploring films. The era of small, shabby nickelodeons had passed, and a new period of increasingly plush movie palaces offering longer and more lavish productions was beginning. Ironically, some of today's most popular Broadway productions are based on movies.

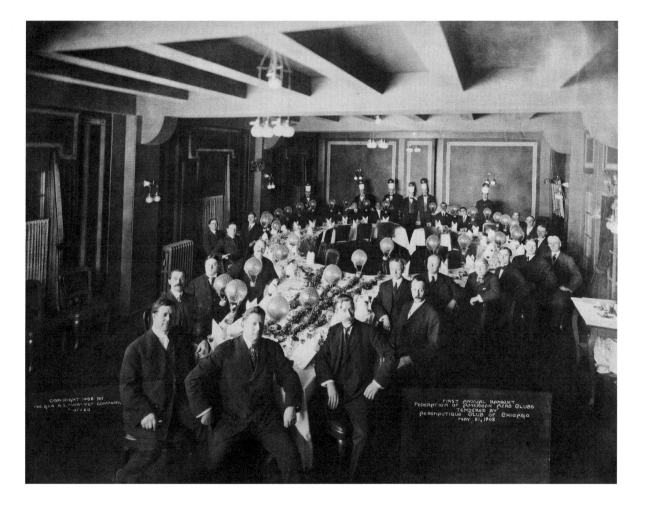

The Wright Brothers launched the first powered aircraft in 1903, at Kitty Hawk, North Carolina, but it hardly triggered an avalanche of development and experimentation. At the time, any tinkerer could build a flying machine in his backyard, and no license was needed to fly it. It remained for private enthusiasts with a vision for air travel and transport to begin transforming flying from an arena for amateurs into a field ripe for business development.

The Aero Club of America was founded in 1905 with such intentions. Charles J. Glidden established the club in 1905 with a few like-minded associates, following the same ideals as the Automobile Club, of which he had been a member. The organization pushed for the regulation of aircraft and air travel, the exploitation of the business potential of flight, and the fostering of technological advances. The Aero Club sponsored air shows and contests and issued the first American pilot's license after World War I. One of its signature accomplishments was the creation and annual awarding of the prestigious Robert J. Collier Trophy, set up in 1911 to recognize the "greatest achievement in aeronautics" of each year. Renamed the National Aeronautic Association in 1923, the organization is still at work, still dedicated to the same goals, and still handing out the Collier Trophy to those who improve the "performance, efficiency, and safety of air or space vehicles."[6]

CONVICTION

It's wonderful to climb the liquid mountains of the sky. Behind me and before me is God, and I have no fears. —Helen Keller

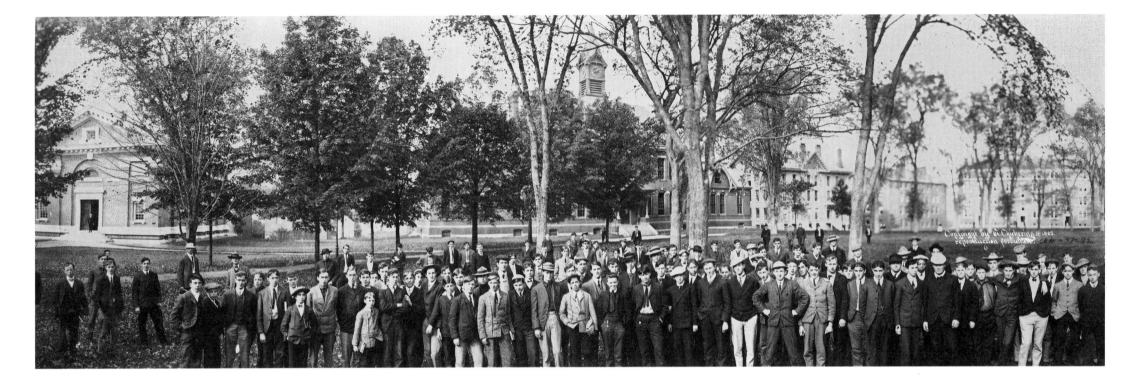

Originally established in 1781 in Exeter, New Hampshire, by merchant John Phillips as a strict, Calvinist school, Phillips Exeter Academy quickly became one of the premier elite private secondary schools in the country.

Coincidentally, the academy's biggest academic and athletic rival—the equally selective Phillips Academy Andover in Massachusetts—had been founded three years earlier by Phillips's nephew, Samuel Phillips Jr.

The schools have remained competitors, with Phillips Exeter considered a stepping-stone to Harvard and Phillips Andover pointing graduates to Yale. At the founding of Phillips Exeter, John Phillips penned a deed of gift in

which he articulated his mission for the school and the ideals he hoped it would instill in its alumni: "Goodness without knowledge is weak and feeble, yet knowledge without goodness is dangerous, and…both united form the noblest character."[7]

Modern pundits write about the religious right as if religion as a social force were something new, but the entirety of American history has been marked by cycles of great religious fervor (and not always in ways that have sat well with conservatives). The history of religion in the United States has been marked by three revival movements known as the Great Awakenings. The First occurred in the 1730s and 1740s, as a wave of passion reinvigorated the already religious; the Second Great Awakening of the early 1800s reached out to the nonreligious, particularly along the country's ever-expanding frontier. Efforts were focused on curing the country's many social ills in preparation for the second coming of Christ. The Third Great Awakening began during the mid-nineteenth century and continued into the twentieth century. Religious evangelists aligned themselves with the Republican Party during the Progressive Era of the late nineteenth century, attacking a spectrum of social ills, including alcoholism, racism, poverty, and child labor. By the early 1900s, evangelism had taken on the form of huge crusades—the ardor of the faithful made all the more forceful by their numbers.

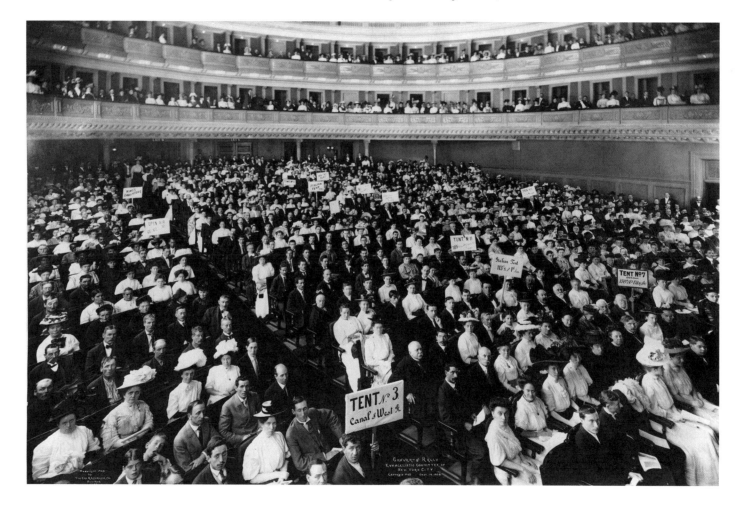

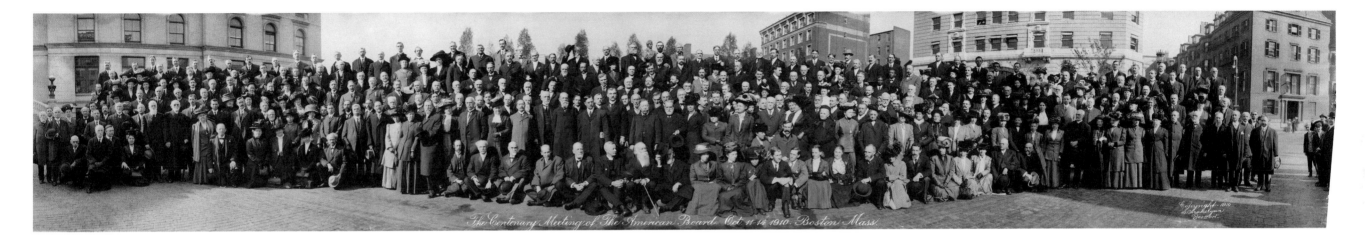

The Centenary Meeting of The American Board. Oct 11 14 1910. Boston Mass.

The American Board of Commissioners for Foreign Missions was an outgrowth of the Second Great Awakening. Immigrants to a young United States saw the country as a pristine, uncorrupted land—a perfect environment in which to restore a pure, unblemished form of Christianity. The members of the new movement evangelized to those in the opening West, enrolled millions into their new Christian sects, and exerted their strength of numbers politically on moral issues, such as temperance, women's rights, and the abolition of slavery. Their goal was to clean up the sins of its citizens in preparation for the second coming of Christ.

The American Board, proposed in 1810 and chartered in 1812, was the first American Christian agency to take the evangelical mission of the Awakening overseas—places the missionaries visited include China, Hawaii, Persia (now Iran), Turkey, Burma (present-day Myanmar), and India. By 1870, however, the movement was in decline, although Christian evangelism and its political influence would resurge in American society time and again. The American Board would continue in its mission into the next century, merging in 1961 with other organizations to form the United Church Board for World Ministries, which still operates today.

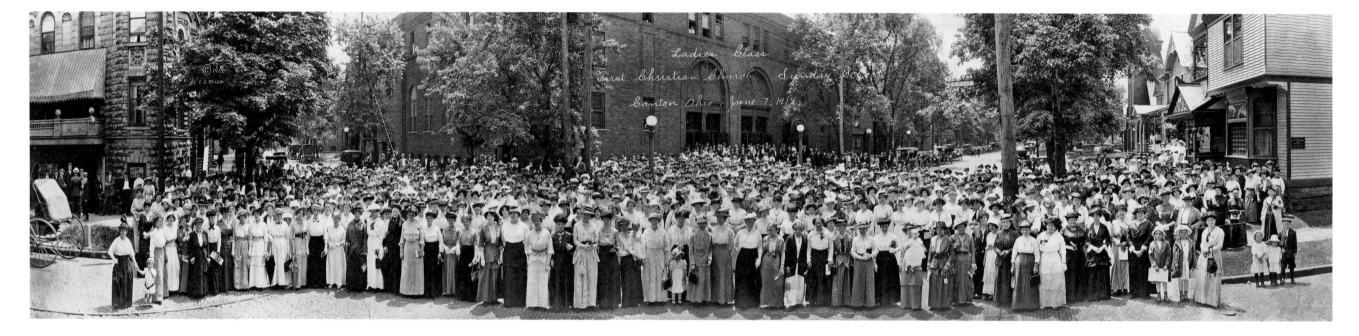

The First Christian Church of Canton was born out of the American Restoration Movement, itself stirred by the Second Great Awakening. That movement splintered into a plethora of independent, if theologically related, congregations.

One of these congregations was the First Christian Church of Canton, organized in 1855 with just thirty-five members and committed to the core values of "Truth, Spirit, Love, Story [meaning the narrative found in the Christian Bible], and Community."[8] At one time boasting the world's largest Sunday school, the congregation continues to grow and remains vibrant.

The Salvation Army—one of the largest social aid organizations in the world—came from humble beginnings. Originally launched in England as the Christian Mission by William Booth and his wife, Catherine Mumford, it became the Salvation Army in 1878. Their daughter, Evelyne, seemed destined to play a prominent role in the organization. She was born on Christmas Day in 1865, the same year the Christian Mission began working in the London slums. By the time she was fifteen, she was already working with the poor in East London. Her enthusiasm and her courage in laboring for the betterment of the disadvantaged never wavered thereafter.

The Salvation Army's presence was often greeted with hostility—by bar owners and even from the Salvation Army's own splinter groups—and Evelyne became her father's go-to talent for facing the sometimes-violent opposition. She eventually rose to the position of commander of the American branch, changing her name to Evangeline to more clearly reflect the dignity of her high-ranking position. She returned to England in 1934 to head the organization as its fourth general and its first female leader and oversaw its expansion into a number of countries around the world.

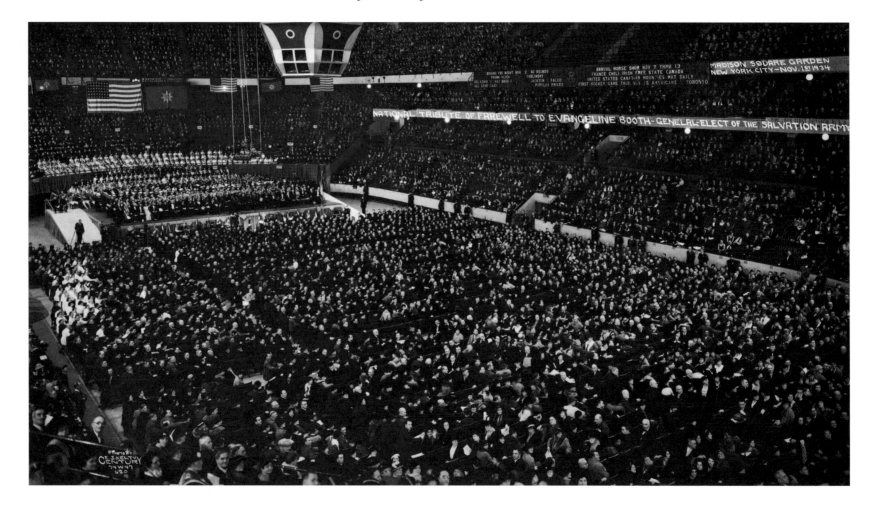

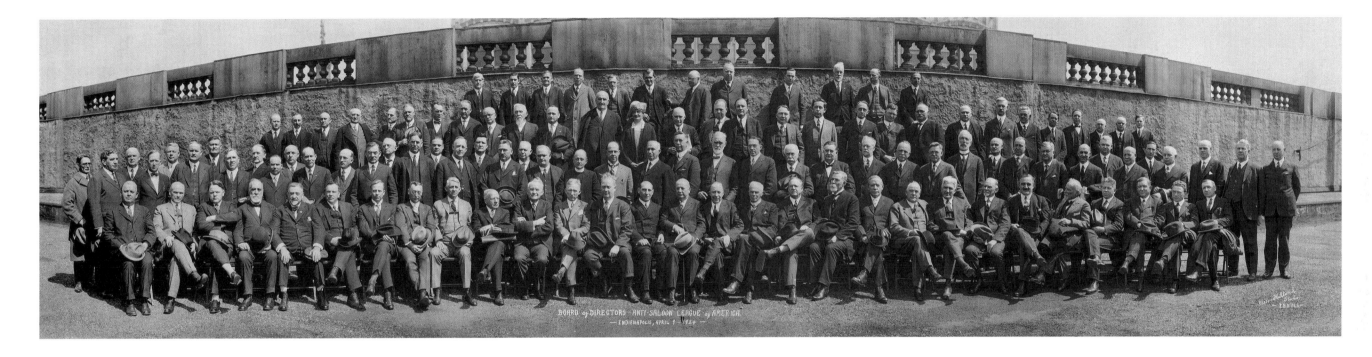

The Anti-Saloon League was a pioneer in tactics now common in American politics. It was a pressure group organized to influence public opinion and advance legislation around a single issue: the prohibition of alcohol. Like many issue-centered groups that followed, it merged zealous belief in its cause with a practical approach to politics. The group cared how legislators voted—not whether or not they drank—and started its own publishing division to promote its views. The league was strongest in the South and rural North, supported by Protestant ministers and their congregations, but made little headway in cities or among Catholics, Jews, or Episcopalians. Unable to thrive in the atmosphere of bootlegging and organized crime that accompanied the Eighteenth Amendment establishing Prohibition, the league failed to counter forces seeking its repeal. The Twenty-Third Amendment passed easily in 1933, making liquor legal once again, and the league faded into oblivion.

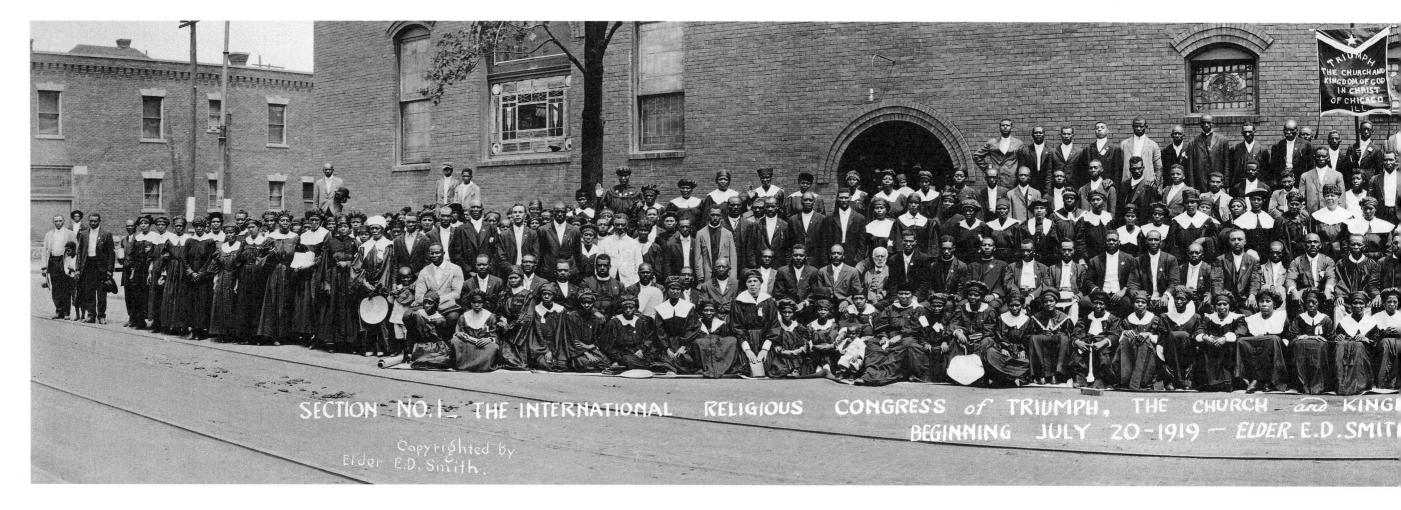

- of GOD in CHRIST. LASTING FIFTY DAYS
POSTLE

Patton's Studio
INDIANAPOLIS
IND.

Triumph the Church and Kingdom of God in Christ was born out of a vision that came to Elias Dempsey Smith, a minister with the African Methodist Episcopal Church, while he was crossing the Mississippi River by rowboat in 1897. According to the church's history, God revealed to Smith an eagle, a lion, and a dark-skinned woman dressed as a bride. Smith, went the divine message, was given a truth higher than that of any other church (symbolized by the eagle), one that would be strong, "mastering every previous limited idea" (the lion), and that would represent both his new church and the entire world (the bride).

Smith's vision spoke to some inner spiritual hunger and his need to find, as the church history notes, "a deeper truth."[9] This inspired Smith to found his own predominantly black Pentecostal church. Although Triumph the Church remains active today, it has always been a splinter sect; by the 1990s, it had less than fifty-four thousand members nationwide.[10]

EQUALITY

All men are created equal; it is only men themselves who place themselves above equality. —David Allan Coe

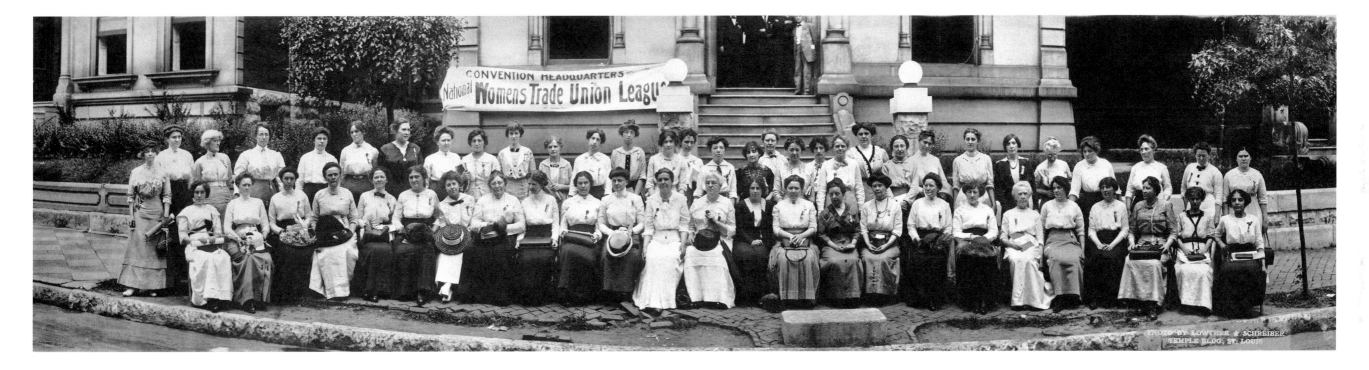

The National Women's Trade Union League of America was founded in 1903 when the American Federation of Labor (AFL) demonstrated that its interest in obtaining fair labor practices did not include obtaining them for women. The league was always about more than addressing poor working conditions for women, concerned with the larger agenda of improving the lot of women in general through education and professional training. The organization was launched and managed initially by wealthy progressives such as Margaret Dreier Robins. During Robins's fifteen years as president, the league expanded in both size and influence. The governing torch eventually passed to working-class women by the 1920s. What recalcitrant employers and a disinterested AFL couldn't do in blunting the league, the Great Depression did, permanently crippling the organization. It limped along for another decade until it was finally dissolved in 1950.
—Kathleen Turner

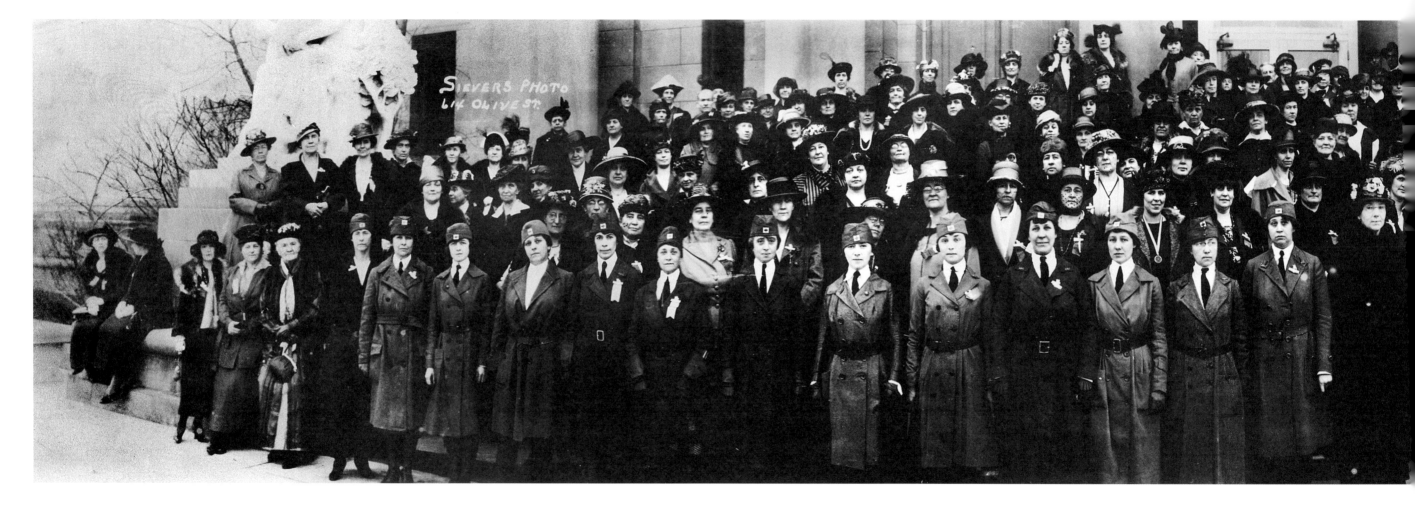

SIEVERS PHOTO
614 OLIVE ST.

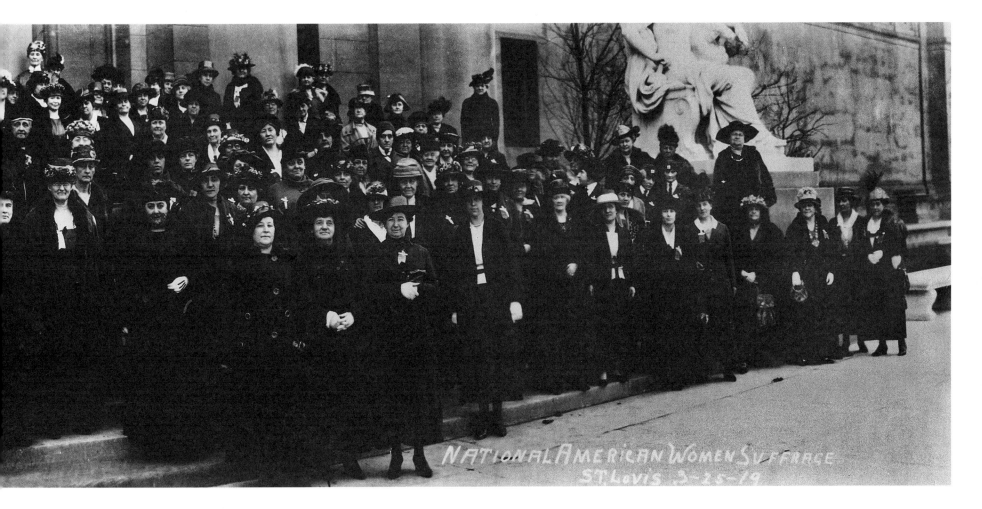

NATIONAL AMERICAN WOMEN SUFFRAGE
ST. LOUIS 3-25-19

From the first articulation of its founding principles, the United States was a paradox. The Declaration of Independence and the Constitution proclaimed equality and liberty for all—as long as one was white and male.

The American Equal Rights Association (AERA) was founded in 1860 as a legislative remedy to inequity. The group split into two organizations in 1869 because of differences between those calling for voting rights for all Americans and those who wanted to focus exclusively on women's suffrage, forming the American Woman Suffrage Association and the more radical National Woman Suffrage Association (which permitted only women to join). In time their similarities outweighed their differences, and the two groups merged in 1890 to form the National American Woman Suffrage Association (NAWSA), becoming the largest and most influential suffrage group on the American political scene. The NAWSA was vital in ratifying the Nineteenth Amendment in 1920, granting women—finally—the right to vote. Although the Nineteenth Amendment fulfilled the founding mission of the NAWSA, the organization did not dissolve, but became the League of Women Voters, dedicated then and now to voter education and registration.

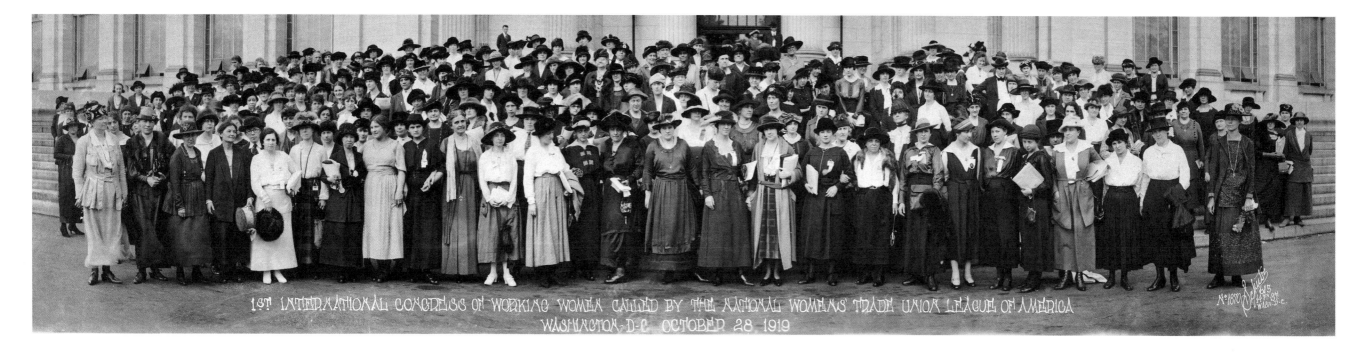

1ST INTERNATIONAL CONGRESS OF WORKING WOMEN CALLED BY THE NATIONAL WOMENS TRADE UNION LEAGUE OF AMERICA
WASHINGTON·D·C OCTOBER 28 1919

Having worked with Maria Shriver and the Center for American Progress on the recent report on the status of women, "A Woman's Nation," I am aware that it was only in 2010 that we reached the tipping point where more people in the US workforce were women than men.

Looking at this photo from almost a century ago, I am struck by the importance of remembering those who blazed the trail for equality and fair treatment for working women: Eleanor Roosevelt, for example, whose extraordinary passion and commitment so benefited the fight for social justice.

Like many of the extraordinary photographs in this book, this one has significant contemporary relevance, as today, in a time of both the Tea Party and Occupy Wall Street movements, we are still struggling to build an economy that works for all. —**Christie Hefner**

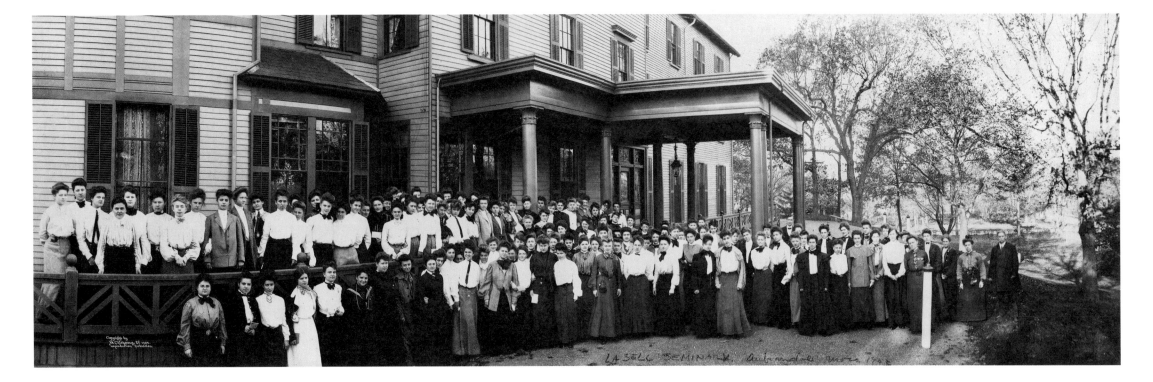

The history of the Lasell Female Seminary is the history of the evolving status of women in the United States written in microcosm. Founded in 1851, Lasell was as much a finishing school for young ladies as it was an educational institution. While their New England male peers were off at the academies at Andover and Exeter being prepped for Yale and Harvard and the assumed contributions they'd make to business and civic affairs afterward, the women of Lasell were being prepped to keep a tidy house and be good company. According to a bragging 1911 advertisement for the school, "Home making in all its phases is thoroughly taught at Lasell. The principles of hygiene, cooking, the art of entertainment, house furnishing and management, sewing, dress-making and millinery are studied in a practical way."

Within a dozen years of women winning the right to vote in 1919, Lasell evolved into a bona fide college awarding associate's degrees. In the space of eighty-odd years, the women of what became Lasell College had gone from learning how to manage a household to learning how to manage businesses. **—Martha Stewart**

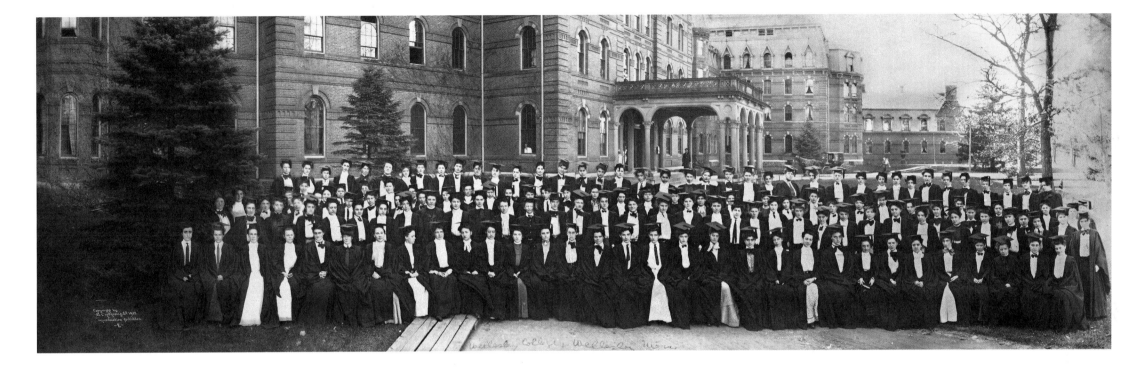

Well into the twentieth century, women in the United States were not only denied the professional opportunities offered to men but also the chance to be as well educated. One of the responses to the male monopoly on higher education was the formation of a network of all-women educational institutions in the Northeast that mirrored the then-all-male Ivy League. Barnard, Bryn Mawr, Mount Holyoke, Radcliffe, Smith, Vassar, and Wellesley were the liberal arts colleges that formed the Seven Sisters.

Founded in 1870 as Wellesley Female Seminary and committed to the spirit of *Non ministrari sed ministrare* (not to be ministered unto but to minister), the institution became Wellesley College in 1873 and turned out its first graduates—eighteen strong— in 1879. The driving concept at Wellesley was the belief that improving the lot of women would improve society as a whole. The college, which was administered and staffed exclusively by women, not only graduated female students, it also, and more importantly, provided a supportive environment that uplifted as well as educated women.

In the late 1960s and early '70s, each of the Seven Sister schools debated whether to become coed. Wellesley—as independent minded as its graduates—retained its women-only policy and does so to this day.

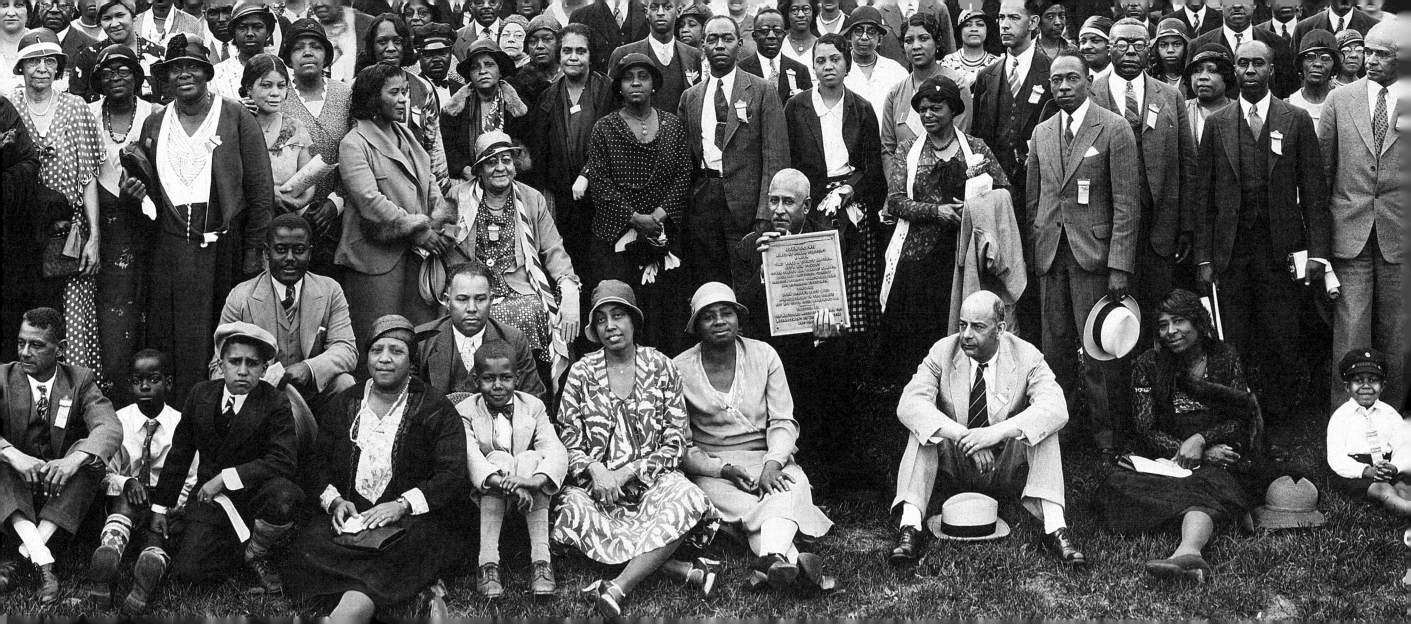

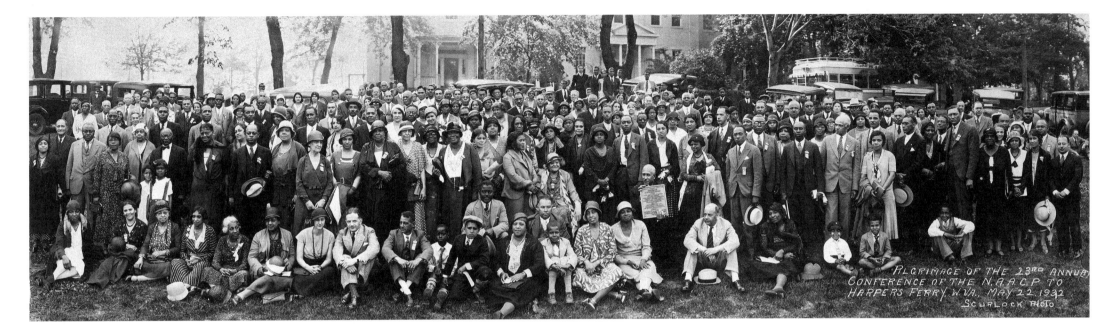

The Civil War did not end the American struggle over race and freedom. The conflict simply moved from the battlefield into the politics and legislative action of the time. Americans settled into a way of life that mainly turned a blind eye to persistent violence against black freedmen, including the horrors of lynching.

The National Association for the Advancement of Colored People (NAACP) was founded in 1909, just forty-four years after the Civil War, as a response to a riot in Springfield, Illinois, the year before. That riot had led to severaldeaths and significant property damage and had prompted a population of more than two thousand blacks to flee the city in fear for

their lives. Concerned that Southern violence might spread to Northern cities, the NAACP dedicated itself to issues of racial justice.

In 1932 the NAACP gathered at one of the first historically black colleges established after the war to educate freedmen. Storer College in Harper's Ferry, West Virginia, had been the home of W. E. B. Du Bois's Niagara Movement,

a precursor to the NAACP. The group wanted to present a plaque to Storer honoring abolitionist John Brown. The college, however, rejected its placement, even though the year before its president had spoken at the installation ceremony of a memorial created by the United Daughters of the Confederacy and the Sons of Confederate Veterans. That memorial was a salute to blacks

who remained loyal to the South, honoring Heyward Shepherd, the first freedman killed in Brown's attempted insurrection. The NAACP criticized the Shepherd memorial as an apology meant to obscure the obscenities of slavery. Storer eventually accepted the tribute to Brown, and it still exists today, along with the memorial to Shepherd. **—John Lewis**

The photograph depicts a gathering of pleasant-looking men and women of the Ku Klux Klan (KKK), assembled in a pastoral setting in Roanoke, Virginia, in 1931. To the uninitiated, they seem to be ordinary people, albeit costumed somewhat fancifully, indistinguishable from any do-good fraternal organization of the time. But we know better.

The KKK was formed after the Civil War in a successful effort to restore white supremacy and intimidate recently freed blacks by committing acts of extreme violence, including murder. In the nineteenth century, indiscriminate shootings of black men occurred frequently on the roads of the South. In the twentieth century, lynchings were preferred. As recently as the 1930s and '40s, there were dozens of lynchings, often for nothing more than the "usual crime" of fraternizing with white women.

My coming of age was June 21, 1964 when the Klan intercepted three young men, participants in the "Freedom Summer," who had hoped to do nothing more outrageous then enroll African Americans as voters. James Chaney and Andrew Goodman were shot dead, and Michael Schwerner was severely beaten before he, too, was shot. The Klan buried the three young men in an earthen dam outside of Philadelphia, Mississippi. I attended Goodman's memorial service in New York City.

We tend to think that evil is committed by fanatics, sociopaths, and the truly psychotic. But this photograph is a reminder that "normal" folks will also commit the unthinkable. Today is no different. In my cases, I encounter "reasonable" prosecutors who invent unindicted co-ejaculators and random necrophiliacs to explain away DNA evidence that is dispositive of innocence. To defend a conviction, they will not hesitate to invent illogical new theories of guilt to keep the wrongly convicted, more often than not black men, languishing in prison or on death row. Nor is it limited to the South. Unspeakable acts are committed everywhere because we allow it. The banality of evil is our collective responsibility. **—Peter Neufeld**

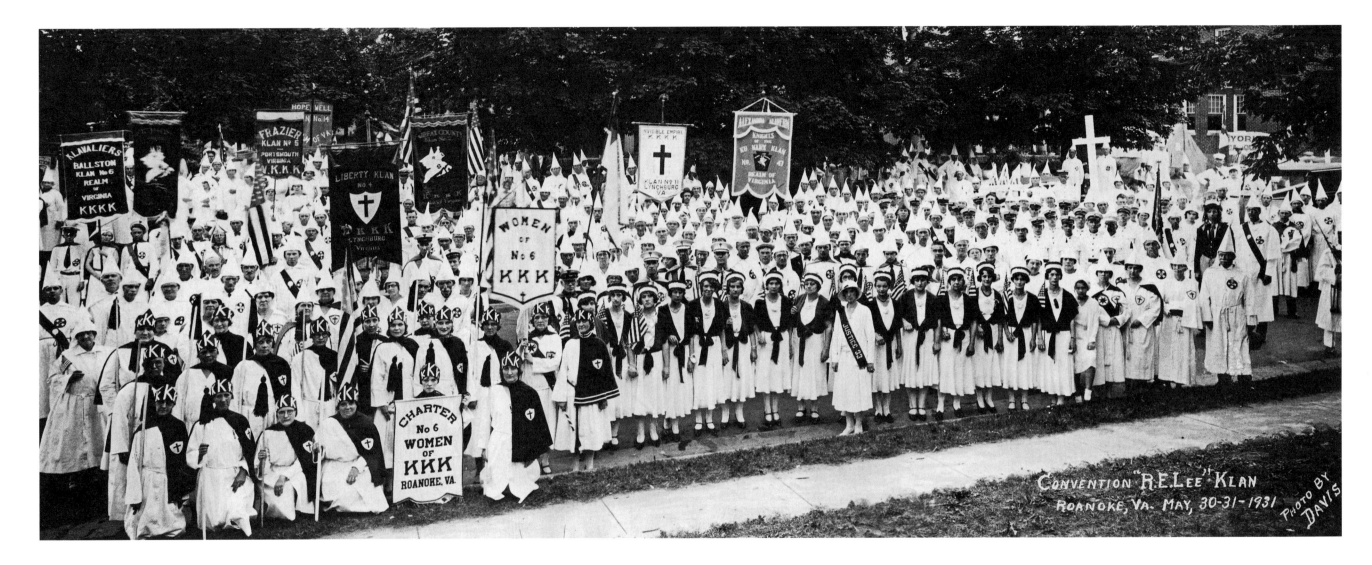

Convention "R.E.Lee" Klan
Roanoke, Va. May, 30-31-1931

Photo by Davis

WAR

In peace, sons bury their fathers. In war, fathers bury their sons. —Herodotus

The 1863 attack on Lawrence by the infamous Quantrill's Raiders was one of the most notorious incidents of the Civil War. William Clarke Quantrill led a band of several hundred Confederate guerillas operating on the border between proslavery Missouri and abolitionist Kansas. The attack on Lawrence was in retaliation against Kansan abolitionists for an earlier assault on Missouri.

Quantrill's men attacked at night and went on a four-hour spree of violence, killing nearly all of the men and older boys and leaving most of the town burning and in ruin. Union forces, in turn, marched into Missouri, forced tens of thousands from their homes, slaughtered their livestock, and torched their fields in an effort to starve Quantrill's operation. It was a classically tragic example of the relentless cycle of violence.

Founded in 1895 by Albert K. Smiley, a respected business leader and a Quaker devoted to the idea of international arbitration, the annual Mohonk Peace Conference began as a small gathering of some fifty people, but ultimately grew to a conclave of three hundred from a variety of fields, from business to religion, government to education. The conference pressed the United States to take a role in defusing the rising tide of militarism in Europe, pushed for and helped create the Permanent Court of Arbitration in The Hague, and fostered any number of efforts to secure peace. Despite the conference's calls "for renewed and persistent efforts on the part of all lovers of justice and good will,"[11] the members were powerless to stop the coming World War I in 1914 and equally unable to end it once it began. The last Mohonk Peace Conference took place in 1916. With an entire generation of European young men being slaughtered in the trenches of the Western Front, the point of the meetings must have seemed academic; though a conference was planned for 1917, it was never held, nor would it ever again convene.

—Mark Halperin

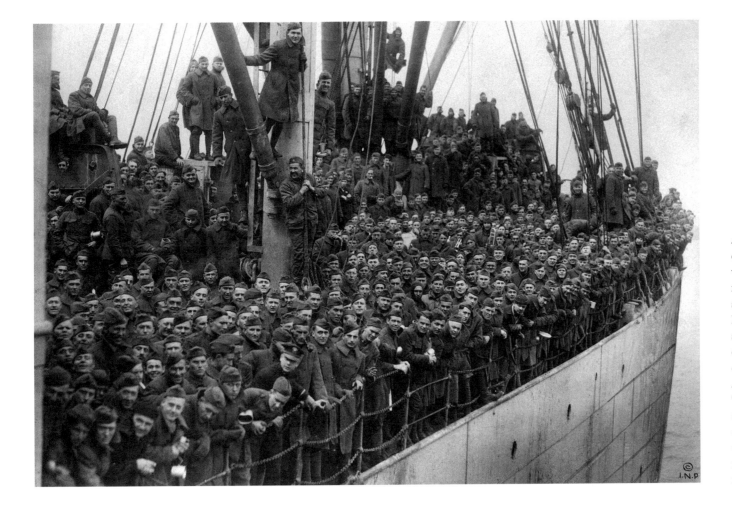

Although the United States formally entered World War I by declaring war against Germany in April of 1917, no significant numbers of US troops saw action until the summer of 1918. More than four million Americans eventually served—fewer than the numbers of the other major combatants—and by the end of the war that November, 323,000 American men had been killed or wounded. This number was small compared to the staggering losses experienced by the Allies during the four years of war: more than three million British and more than six million French casualties. The butcher's bill for the entire war was appalling: more than thirty-seven million total casualties, with nearly an entire generation of Europe's young men lost in the muddy, rat-infested trenches of the Western Front.[12]

The memory of the carnage in the European trenches would haunt the United States for years—shaping its literature and films, leading to a foreign policy of isolationism, and bringing about a vow that never again would the nation send its boys to die in someone else's war. It would take another, even more devastating conflict to reveal how small and interconnected the world had become in the twentieth century; no ocean or distance would be vast enough to keep the United States isolated from world affairs.

At the time the United States declared war on Germany to enter World War I, its pitifully small army (less than one hundred thousand men) was no match for the Kaiser's troops and could not offer much support to its new British and French allies. A massive and immediate build-up was required.

The Selective Service Act, passed soon after the declaration of war, put more than four million Americans in uniform before the end of the war. Training camps, including South Carolina's Camp Sevier, were quickly set up around the country. Erected in 1917, Camp Sevier was initially little more than a massive tent city, but eighty thousand newly minted soldiers would ultimately pass through its gates—including the Thirtieth Division, whose members earned twelve Congressional Medals of Honor. By the summer of 1918, thanks to training bases like Camp Sevier, the United States was sending ten thousand soldiers to the Western Front every day.

Neither the four-million-man army nor the posts that turned them out were ever intended to be permanent: of the three training camps set up in South Carolina during the war, only one—Fort Jackson—remains in operation. Camp Sevier was deactivated in 1919.

There are probably no better examples of the effusive patriotism that accompanied the United States' entry into World War I than the "living photographs" and "living insignias" depicted here. Massive numbers of people came together to create these grand-scale representations; the resulting photographs signified the country's unity of purpose and boundless resources—they were a big country's way of saying something big in a big way.

In 1918, twenty-five thousand men at Camp Dix composed this living Liberty Bell; the living insignia of the Eleventh "Lafayette" Infantry Division was formed at Camp Meade, which, like Dix, was one of the numerous training camps quickly set up following the 1917 Selective Service Act. Before the war was over, Camp Meade would train one hundred thousand men as well as twelve thousand horses for combat overseas (like other nations' armed forces of the time, the US military still employed mounted cavalry and heavily depended on horses to move supplies and equipment). Unlike most of the camps hastily erected in 1917, both camps—later renamed Fort Dix and Fort Meade—are still in operation today.

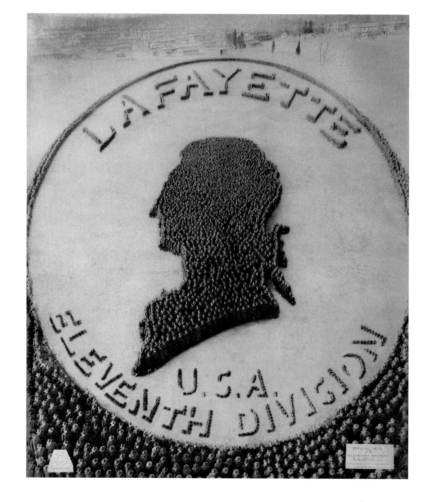

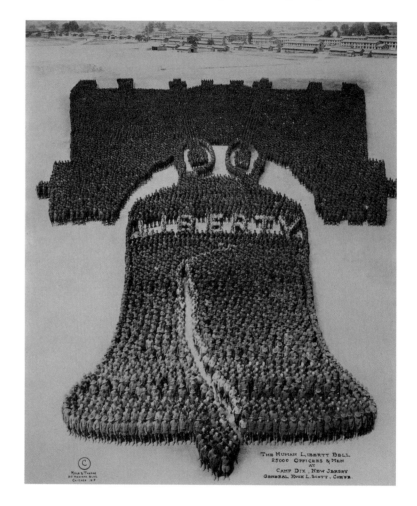

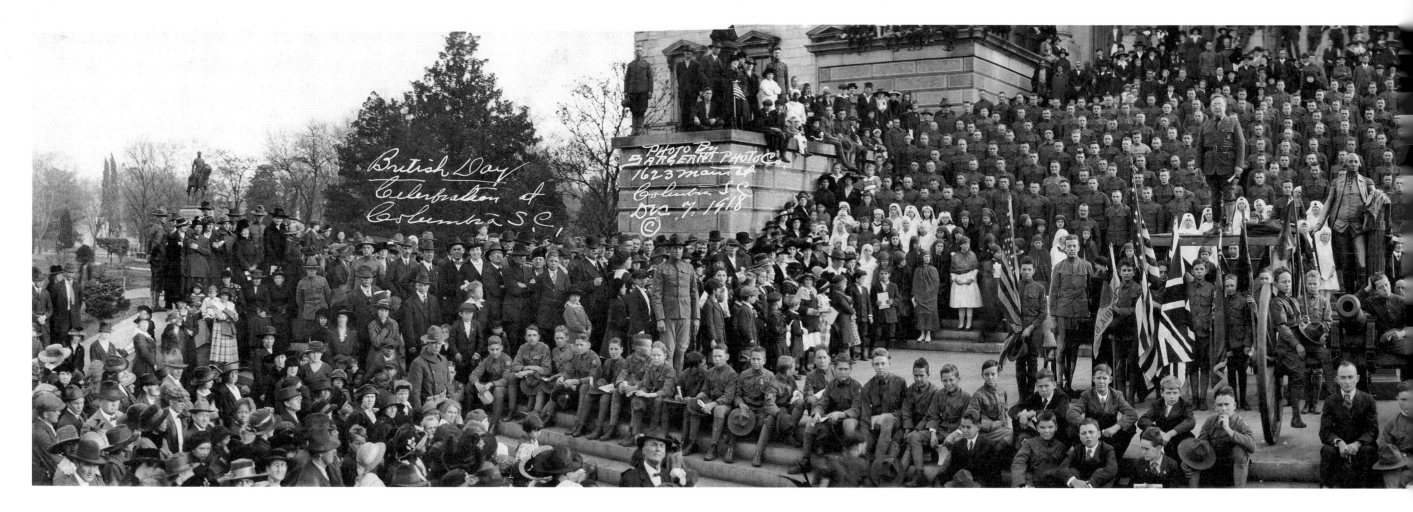

World War I concluded in November of 1918 after four years of the most brutal bloodletting in the history of warfare up to that time. In the euphoria that followed the armistice, the two Allies with the closest kinship, Britain and the United States, saluted each other with British Day celebrations in cities across the United States; this one took place on the grounds of South Carolina's state capitol. Messages from King George V and President Woodrow Wilson were read, their nations' respective tragic losses memorialized, and the bond between the two countries reaffirmed.

In the months between the onset of World War I and the United States' involvement, public sentiment evolved from apathy to ardent commitment. The war had become— after almost three years of reports of atrocities (some true, some not, some propaganda), including German U-boats sinking unarmed civilian ships—a fight to protect freedom and democracy in the eyes of Americans.

Men were not the only ones to respond to the call to arms. Some 13,000 women enlisted in the Navy, Marines, and Coast Guard, usually filling clerical jobs to free up men for frontline service. An additional 21,500 women served as Army nurses (more than 400 died, mainly from disease). To support the uniformed personnel, many patriotic groups formed at home.

The war had a major impact on the role of women: thousands entered the workplace to fill the positions vacated by men. The capabilities and independence women demonstrated significantly contributed to the eventual success of the suffrage movement.

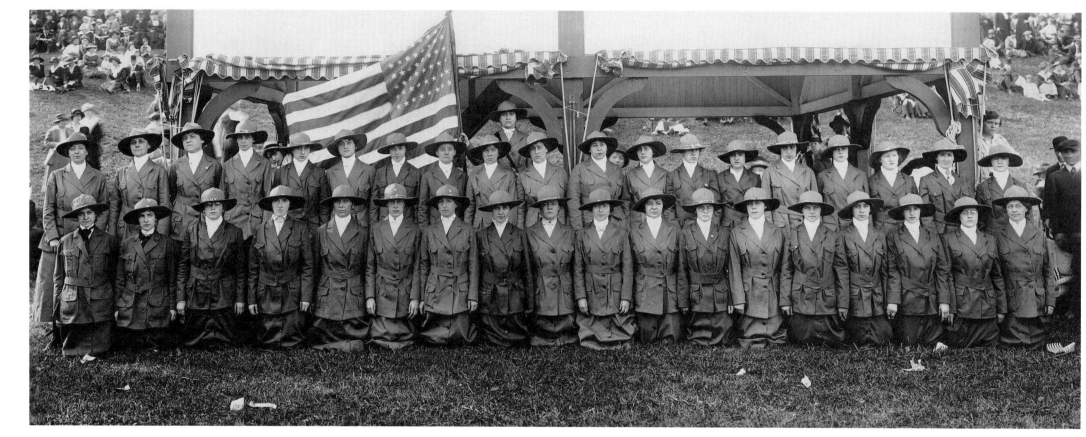

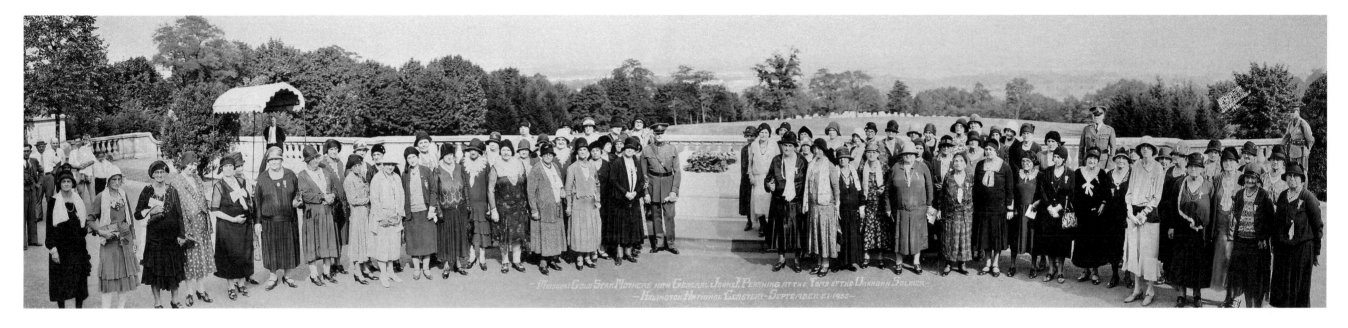

One of the most memorable pieces of mythology in my family is the story of how my Uncle Frank was taken prisoner during World War II, and how my grandmother made a deal with God that she would give up candy if he came home alive. I remember, as a child, feeling sorry for my grandmother; I didn't understand until I was a mother myself that a life without chocolate-covered cherries was a very, very small price to pay for having your son walk back through the door.

I think that's when I first heard of the Gold Star Mothers, the group of women who have lost children who served in America's wars. These members of a Missouri chapter are posing with General John J. Pershing at the Tomb of the Unknown Soldier at Arlington in 1930; given the date, their sons probably died in World War I, as did the son of the organization's founder. A service flag went up in the window when a son deployed, with a blue star; the blue was replaced with a gold star if he was killed. Today, Gold Star Mothers have daughters as well, who have died in places like Iraq and Afghanistan. **—Anna Quindlen**

CO 1521 CCC Camp Muskingum SCS-22
Zanesville O May 10th 1938

John H. Murphy Co.
Cleveland O.

Black Americans have fought alongside white Americans in every war, yet no amount of blood shed by black soldiers seemed sufficient to earn them respect—let alone equality—at home. In fact, blacks were generally prohibited from enlisting in the US Army (by a 1792 law) until the Civil War, although many still found ways to serve.

Black participation in World War I proved, sadly, to be no exception. In the country's run-up to a war footing, the Army was quick to induct blacks (350,000 before war's end), but then often subjected them to second-class (and sometimes abusive) treatment in all-black or segregated camps and relegated most to support units.

Nonetheless, the black units that did enter combat performed admirably. Corporal Freddie Stower of the all-black 371st Infantry Regiment posthumously earned the only Medal of Honor won by a black soldier serving in the war. The 369th Infantry Regiment, the Harlem Hellfighters, served in combat longer than any other American unit during the war, at a cost of fifteen hundred casualties. Despite the contribution of the 369th (and representative of the treatment of black soldiers), the regiment was not allowed to march with other Allied troops during the Paris victory marches or in the New York Victory Parade of 1919. The American military would remain segregated for almost three more decades until integrated by executive order of Harry Truman in 1948.

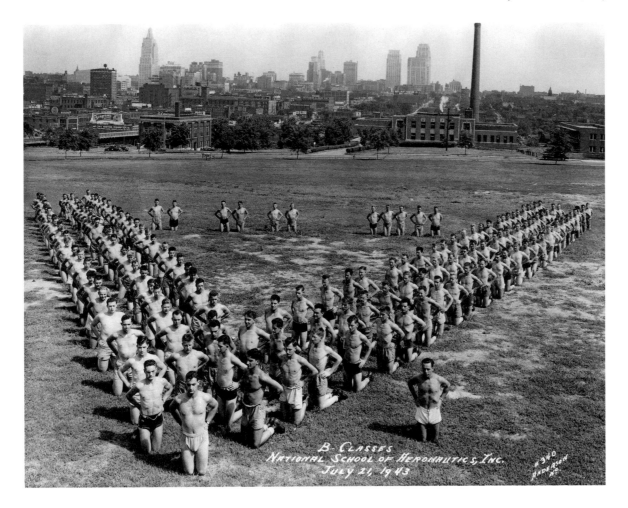

In grandly tragic fashion, the "war to end all wars" would be eclipsed a mere two decades later by a bigger, bloodier conflict: World War II. But this time, the United States did not spend nearly three years deciding if it had a vested interest in the outcome. After the Japanese attack on Pearl Harbor on December 7, 1941, followed by Germany's declaration of war on the United States, there was no question about taking up arms.

Germany had already been at war in Europe since 1939 and the Japanese in Asia as early as the 1920s, during which time both countries had amply demonstrated their brutality. Behind all of the patriotic rhetoric, it was clear that this was a war for survival. With the horrific conduct of the Axis powers in mind, the necessity of going to war was manifestly clear. Rarely before, and perhaps not since, has the nation come together with such clarity of purpose and wholesale commitment—characteristics on full display in this staged photo taken at one of the many flying schools the Army contracted to train pilots. The trainees form a massive "V for Victory."

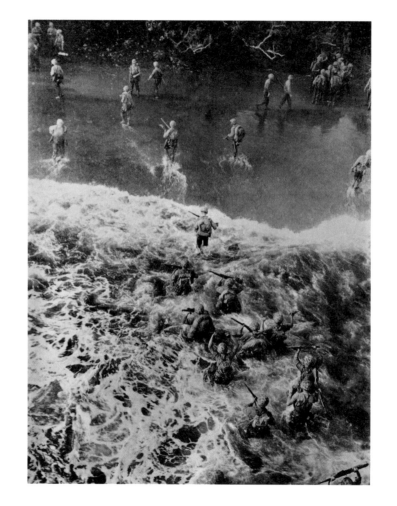

A new war brought new iconography. The images from the Great War—World War I— had been shaped by the static yet sanguinary battle for the trenches that had stretched from Switzerland to the English Channel. For much of World War I, the front line did not shift more than twenty miles in total. It was a horrible battle of attrition that turned the pastures and forests of northern France— fought over time and again—into a muddy moonscape of shell holes littered with piled and rotting bodies.

World War II, in contrast, was a war of maneuvers, and no place were the distances traveled greater than in the Pacific theater, as troops leapfrogged their way from one Japanese-held island to another. From the first American offensive landing against Guadalcanal in 1942 until the last, brutal island battle of Okinawa in 1945, the image of American Marines storming a tropical beach became a recurring—even emblematic— image of the war against the Japanese.

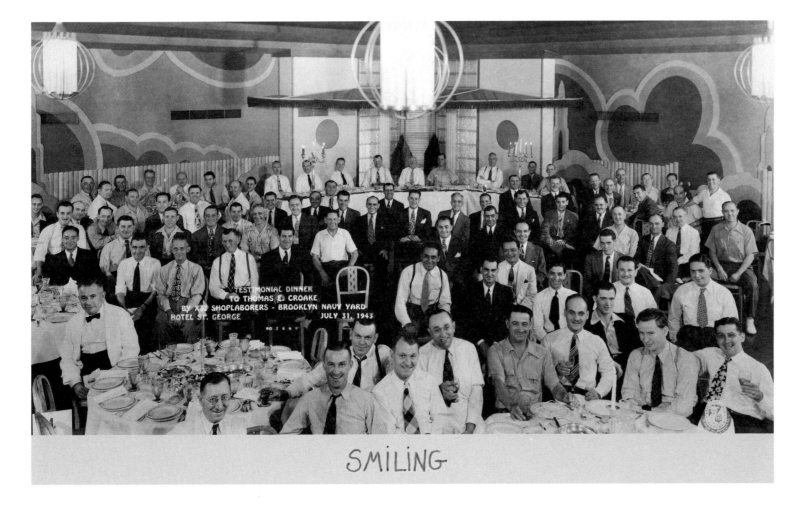

TESTIMONIAL DINNER
TO THOMAS E. CROAKE
BY XTZ SHOPLABORERS · BROOKLYN NAVY YARD
HOTEL ST. GEORGE JULY 31, 1943

SMILING

Americans who lived through World War II remained confident of an American victory, even during the darkest days of the war, when Europe was completely under the heel of Nazi Germany and the Japanese ran rampant in the Pacific. It was a testament to American resilience (and the ability of President Franklin D. Roosevelt to energize a population that had already been suffering through twelve years of the Great Depression) that in the aftermath of Pearl Harbor and Wake Island and the fall of the Philippines, the American Pacific fleet crippled and its Army woefully small (just 174,000) and fielding obsolete equipment, Americans continued to work—some under arms, some in the factories that made those arms—to win the war. Munitions factories, production lines turning out military vehicles, and shipyards (like the Brooklyn Navy Yard) ran around the clock, running two and often three shifts. The result was that by July of 1943 the United States was well on the offensive in the Pacific; the Germans and Italians had been chased out of North Africa; the Allies had landed in Sicily; and the US Navy had grown to be the biggest naval force in the world, larger than the navies of all the other World War II combatants combined.

COMMUNITY

Brotherhood is not just a Bible word. Out of comradeship can come and will come the happy life for all. —Heywood Broun

Red Cloud and Lakota delegation visiting the White House — *Washington, DC, 1871*

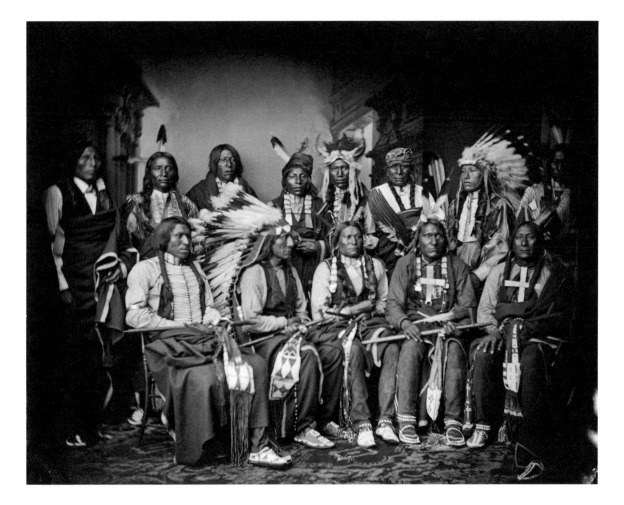

I love this picture because these are my relatives. (I'm an "adopted" American Indian; both Crow and Sioux.) Look at the great war chief whose name has puzzled for years: "Young Man Afraid of His Horse." At the Pine Ridge reservation, I chatted about him with a young Sioux woman, and her grandmother, sitting nearby, asked what we were saying. Her daughter told her. Grandma laughed heartily, saying, "That was not his name!"

And so, at last, I learned the great warrior's true name. It was "Even His Horse Makes Men Afraid." Wow! —**Dick Cavett**

Seated, left to right: Yellow Bear, Jack Red Cloud, Big Road, Little Wound, Black Crow. Standing, left to right: Red Bear, Young Man Afraid of His Horse, Good Voice, Ring Thunder, Iron Crow, White Tail, Young Spotted Tail. Photograph by Mathew Brady[13]

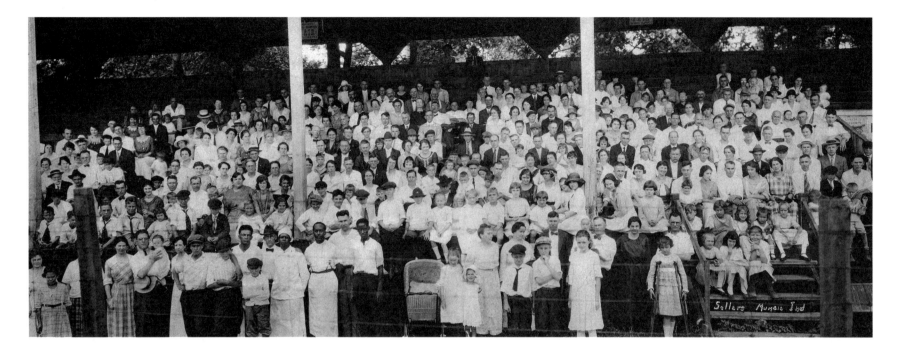

In 1924 Columbia University sociologists Robert S. and Helen Merrell Lynd moved to Muncie, Indiana, intending to study the religious life of its inhabitants. Their study expanded into an examination of many more facets of the residents' lives, and in 1929 they published their landmark book *Middletown: A Study in Contemporary American Culture*. The Lynds' work kicked off sixty years of research on Muncie—often referred to as "the most studied city in America"—as a barometer of the American psyche. (As would be expected for the time, the Lynds' study completely ignored the city's black community.) The Lynds returned again to study the town, which resulted in their 1937 work *Middletown in Transition*. As recently as the 1980s, Peter Davis oversaw a six-part *Middletown* video documentary inspired by the books.

Thanks to the attention the Lynds brought to Muncie, many photographers documented it, including Margaret Bourke-White, whose work became a 1937 photo feature for *Life*. But arguably no one did as good a job of presenting the mosaic of Middle America as Muncie's own Otto Sellers. Born in Germany in 1868, Sellers emigrated to the United States as a young man and spent ten years working in Muncie's steel mills before becoming a photographer. From the turn of the twentieth century until his death in 1940, Sellers compiled an impressive body of work: images of factory floors, family gatherings, landmark buildings, graduating classes, and even a Ku Klux Klan meeting, providing a complete portrait of a city growing and evolving through the first decades of the twentieth century.

Pictured here is a municipal gathering that took place in the Akron area sometime during the early twentieth century. What's worth noting—and not uncommon for the time—is that the outdoor setting is a re-creation of an indoor meeting room, with podiums, ranked chairs, desks, and even tabletop bouquets. Come warm weather, a significant portion of the United States either moved outdoors or closed down completely. In cities, tenement dwellers slept on fire escapes during sweltering summer nights; in rural areas, breezy screened porches served as summer bedrooms. Today's school summer vacations and Congress's summer recesses, for example, are vestiges of a time when it was simply impossible to conduct indoor activities because of the summer heat.

The technology of cooling air goes back to the ancients, who fanned air across ice. In 1902 Willis Haviland Carrier devised what he called an Apparatus for Treating Air— the first electrical air-conditioning unit (the term "air conditioning" was coined four years later by Stuart Cramer for his own cooling system). The first air conditioners were cumbersome affairs used to cool large buildings, such as department stores or theaters. They were also a bit dangerous—like early refrigerators, they used toxic or flammable chemicals. It was not until 1928 that the much-safer Freon came into use; the same year, Carrier invented the Weathermaker, the first unit designed for home use. In time, air conditioners became more compact and more affordable, and all parts of the United States—even the South and Southwest— became not just tolerable but comfortable.

RIGHT AND OPPOSITE ⟶

The first publicly funded fire department in the United States was created in Boston in 1679, but the governmentally sponsored fire department was not common during much of the country's early history. During the late eighteenth century, most fire companies were set up by fire insurance companies and would put out fires only in buildings insured by their parent company. It was not until the nineteenth century that American cities began forming their own centralized fire departments.

In 1822, when St. Louis was still called Mound City, the mayor created the city's first organized firefighting effort: it was effectively what we would call a volunteer fire department. The firemen may not have been trained professionals, but each of Mound City's eleven fire companies took great pride in its work, and the units would often race each other to be first to a fire. St. Louis eventually combined its fire companies into a single paid fire department in 1857, with firehouses—like those of most city fire departments—becoming very much social gathering places for company members. As a general rule, municipal funding for fire brigades was not paid to individual members, but to the firehouses, to be used as the members saw fit.

Knox Automobile in Springfield, Massachusetts, rolled out the first modern fire engine in 1905, and the following year Springfield's firefighters became the country's first motorized fire company. It did not take long for fire companies throughout the country—such as this one in Middletown—to follow suit, switching over from horse-drawn pumpers to fire engines. Knox went out of business by 1914; thereafter, Middletown acquired fire engines made by Seagrave Fire Apparatus, which is still today one of the most well-known suppliers of firefighting equipment.

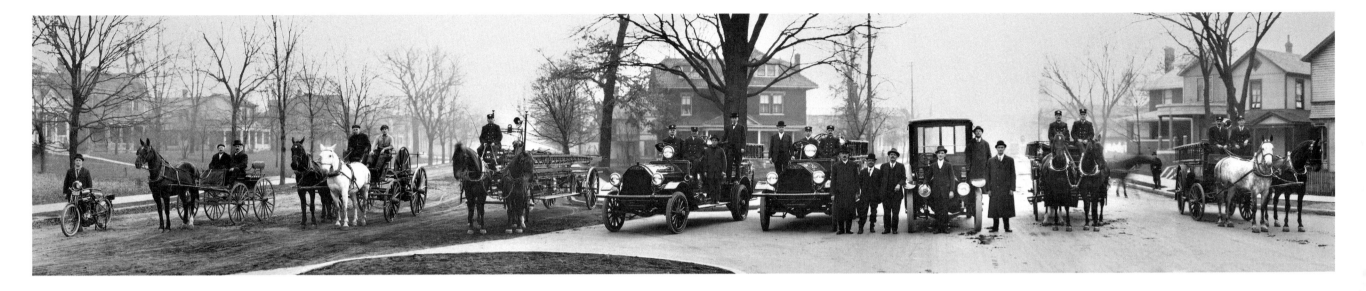

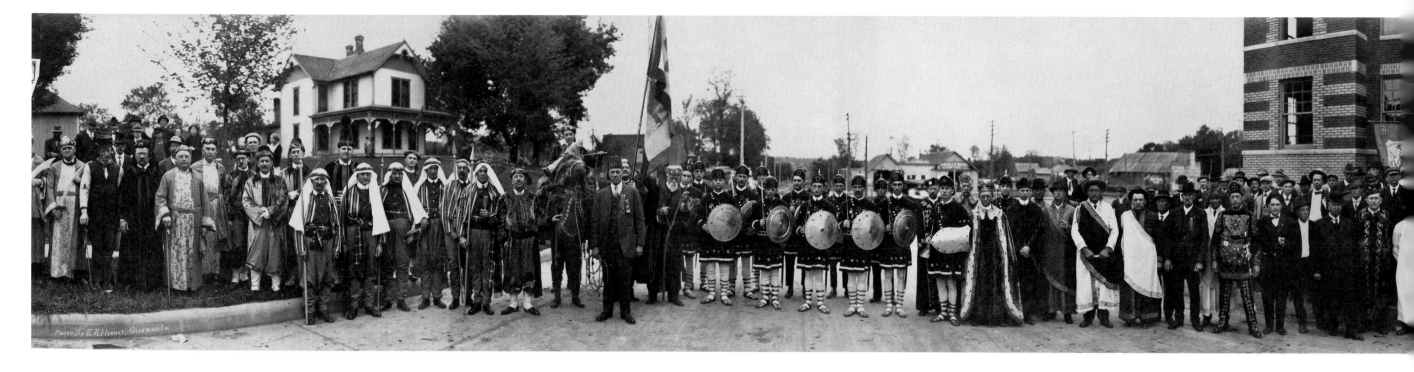

Fraternal organizations have long been so integral to the American social makeup that as early as the 1830s, the great historian Alexis de Tocqueville described the country in his *Democracy in America* as "a nation of joiners." By the early twentieth century, the number of memberships in fraternal organizations equaled the total number of adult males in the country. To the outsider, they may have all seemed the same: assemblies of hobnobbing men, enacting arcane rites and sometimes cloaked in bizarre costumes. But the members of each group pledged to a distinct set of principles.

The Knights of Pythias (the name derives from the ancient Greek legend of Damon and Pythias, whose story was a paean to friendship) was founded during the Civil War with the hope of healing the nation from the traumas of war. President Abraham Lincoln was so moved by the noble intentions of the Pythians—whose motto is "peace through understanding" and who follow the principles of friendship, charity, and benevolence—that he declared: "If we could but bring [the Pythians'] spirit to all our citizenry, what a wonderful thing it would be."[14]

At Lincoln's urging, the Knights of Pythias became the first fraternal organization chartered by an act of Congress. Ironically, for a group dedicated to peace among men, each new member received a ceremonial sword. Swords and spears remain a part of the Pythians' rituals to this day.

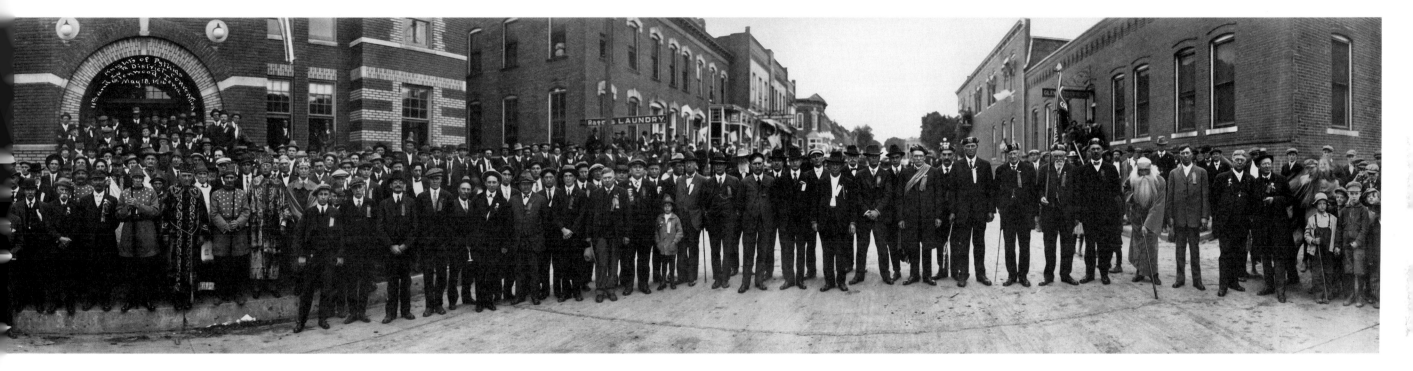

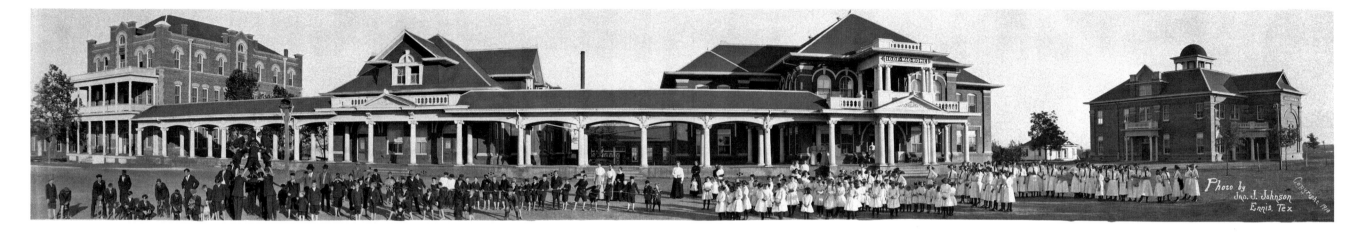

Photo by Jno. J. Johnson, Ennis. Tex

ABOVE AND OPPOSITE ——→

Despite the difficulties of day-to-day life in sixteenth-century England, there were those good souls who maintained a concern for the well-being of others. They joined together and pooled what they could spare of their meager earnings to help those among them in need. Such purity of purpose was considered so rare that the members of these groups were called Odd Fellows.

The groups became organized societies, and the first American chapter of the Independent Order of Odd Fellows (IOOF) was founded in Baltimore, Maryland, in 1819. As the country expanded westward, so did the Odd Fellows. The Odd Fellows of Texas opened the Odd Fellows Widows' and Orphans' Home in Corsicana in 1886, and two thousand family members of the order were cared for at the home until its closing in 1991.

Despite its altruistic aims, the Odd Fellows was plagued by the double standard that existed in many fraternal organizations in the country's early days, excluding women from their organization. After much debate, the order began conferring honorary "Rebekah" degrees to the wives and daughters of Odd Fellows members in 1851, but it was not until 1868 that the Daughters of Rebekah was allowed to establish its own lodge system mirroring its male counterpart.

Long after women had gained the right to vote, such single-sex preserves were still slow to integrate. The Benevolent and Protective Order of the Elks, for example, did not admit women until 1995. The discriminatory practices of the Odd Fellows and the Daughters of Rebekah, too, eventually ceased, and they now have members of both genders. Today, the Odd Fellows has ten thousand lodges in twenty-six countries, and its members remain committed to its founding "three links": friendship, love, and truth.

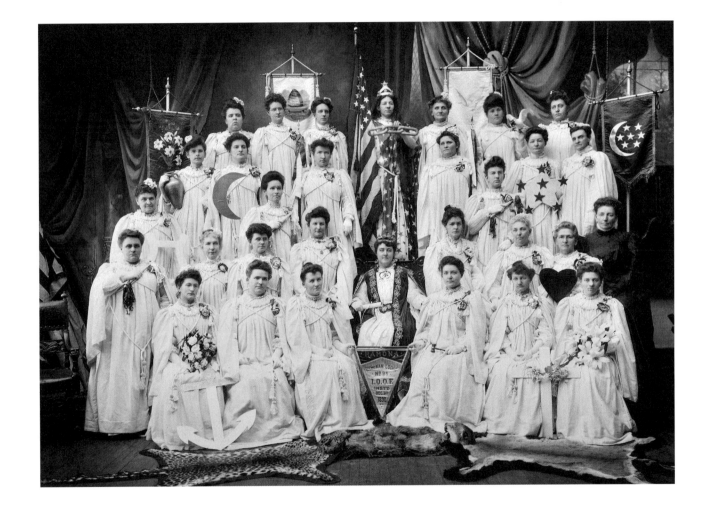

The Benevolent and Protective Order of the Elks (BPOE) was founded in 1868 by a group of actors and musicians looking to form a private club to get around New York's "blue laws." These laws mandated that saloons and taverns close on Sundays. The original name of the group—suggesting less inspirational goals than those now associated with the Elks—was the Jolly Corks.

While the aspirations of the Elks became more laudable over time, racial integration was long in coming. The BPOE pushed blacks to form their own group in 1899: the Improved Benevolent and Protective Order of the Elks of the World (aka the Black Elks). The reaction of some white chapters of the BPOE was far from accepting: for example, Black Elks cofounder Arthur J. Riggs, a Pullman porter, was pushed out of his job and threatened with lynching by Elks from Birmingham, Alabama. Riggs eventually had to relocate with his family and changed his name.

Although the parallel organizations agreed to coexist in 1918, the bylaws that kept the BPOE all white were not changed until 1972, and one Florida chapter did not open its doors to blacks until 1985 (women would not be admitted until 1995).

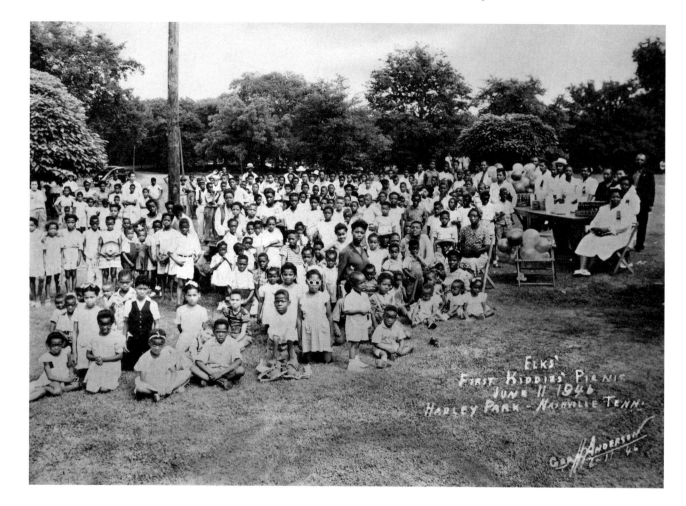

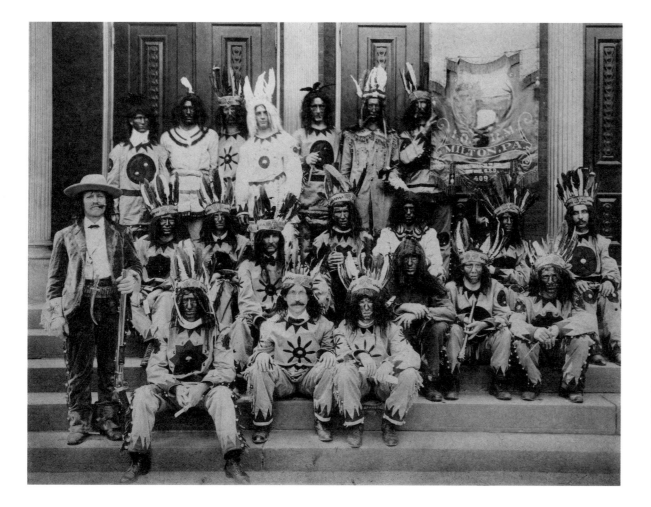

Although founded in Baltimore, Maryland, in 1834 as a workingman's drinking society, the Improved Order of Red Men can trace its beginnings to pre-Revolution secret societies that fought against English tyranny, particularly the Sons of Liberty. The Improved Order of Red Men was inspired by the philosophical underpinnings of the Iroquois and emulated tribal practices in both its rituals (which carry frequent references to "the Great Spirit") and wardrobe. In the spirit of the Iroquois, they focused on hospitality and taking care of those members who fell on hard times: membership dues paid for disability payments and even medical care for fellow Red Men.

The Improved Order of Red Men espoused fellowship, although its bylaws flatly stated that only "free white male[s]" were eligible for membership. In the 1950s some Californian Red Men pointed out the irony of an organization dedicated to the philosophies of Native Americans that banned Native Americans from membership, but their move to repeal the restriction was defeated. The Improved Order of Red Men remained closed to nonwhites until 1974. At its peak in 1935, the Improved Order of Red Men—which claims to be America's oldest fraternal organization— had about a half million members. But, like most societies of similar vintage, it has had little appeal to later generations and currently counts fewer than thirty-eight thousand in its ranks.

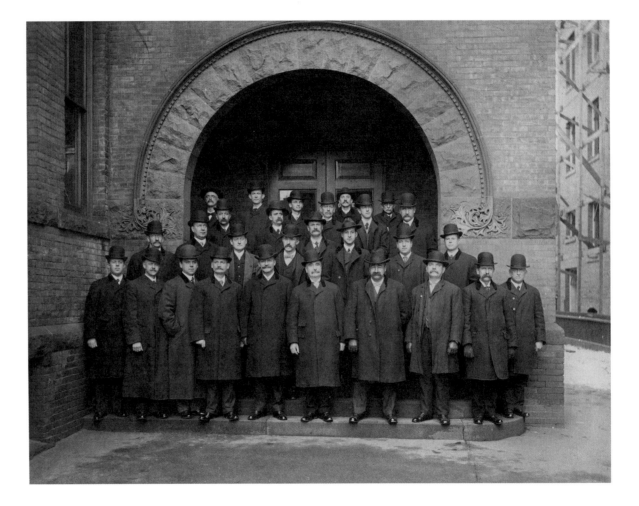

Despite being England's wayward child, the United States of the nineteenth century— at least in well-developed cities and towns and particularly among the upper classes— embraced many Victorian characteristics, such as a rigid formality and a level of prudery. Even those engaged in the hardest of physical labor in unbearable heat thought twice before removing their long-sleeved undershirts. This tightly buttoned sense of decorum lasted well into the twentieth century.

This picture of the Springfield city council perfectly illustrates the severity of the customs of the time. The derby hat was introduced in England during the 1850s; by the end of the nineteenth century, the monochromatic derby and overcoat had become the standard look of the English city gentleman. It was apparently adopted almost as a uniform by the good councilmen of Springfield.

One of the enduring contradictions of the United States has been that despite its founding principles of equality and liberty, for much of its history a profound intolerance has faced those who commit what the social mainstream has considered offenses against good morals. Such offenses typically have included any behavior that hasn't conformed to a rather narrow—and, by contemporary standards, naive and uninformed—perception of human relationships and sexuality.

At a time when polite society didn't even use the word homosexual (Lord Alfred Douglas's 1894 poem "Two Loves" refers to "the love that dare not speak its name"), any form of sexual unconventionality was considered an abomination. In the years between 1848 and the start of World War I, twenty-one states and thirty-one cities passed laws banning cross-dressing. These laws were often part of a wider range of bans on supposedly indecent behavior, and served as a way to restrict, repress, or punish homosexuality. All that in mind, this photograph represents a form of clever rebellion: what better way to defy such a law than to violate it by dressing as the very sort of patriarchal figures who had conceived it?

SPECTACLE

Every man has his follies—and often they are the most interesting things he's got. —*Josh Billings*

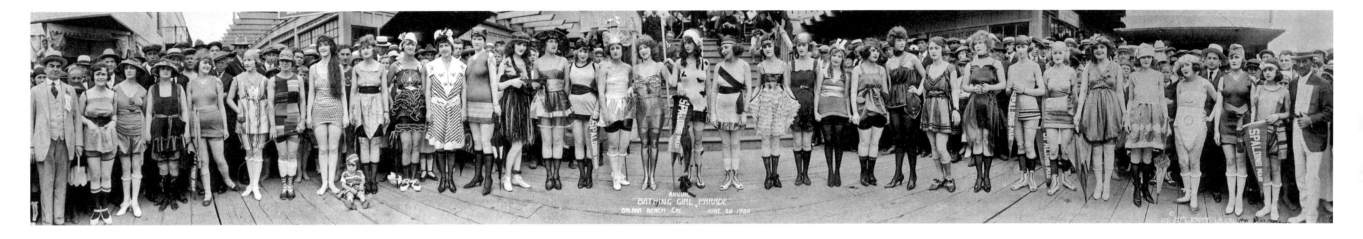

This photograph of the annual Balboa Beach Bathing Girl Parade captures the transition between the nineteenth-century women's swimwear designed for modesty and the twentieth-century swimwear that acknowledges the female body and encourages women to enjoy the water, just as men have enjoyed the water. It is not surprising that as women gained their political and civil rights, their bathing suits became more functional and less confining; the women themselves became more visible as colors became more vibrant.

As swimming became more popular, women demanded more practical bathing suits. The bloomers dropped off. The bonnets and the pants disappeared. The leggings and the hats were left at home. Bit by bit, through the first decades of the new century, women's bathing suits grew smaller and sleeker, accenting the grace of the female form rather than concealing it, as is the case with all good fashion. **—Kay Unger**

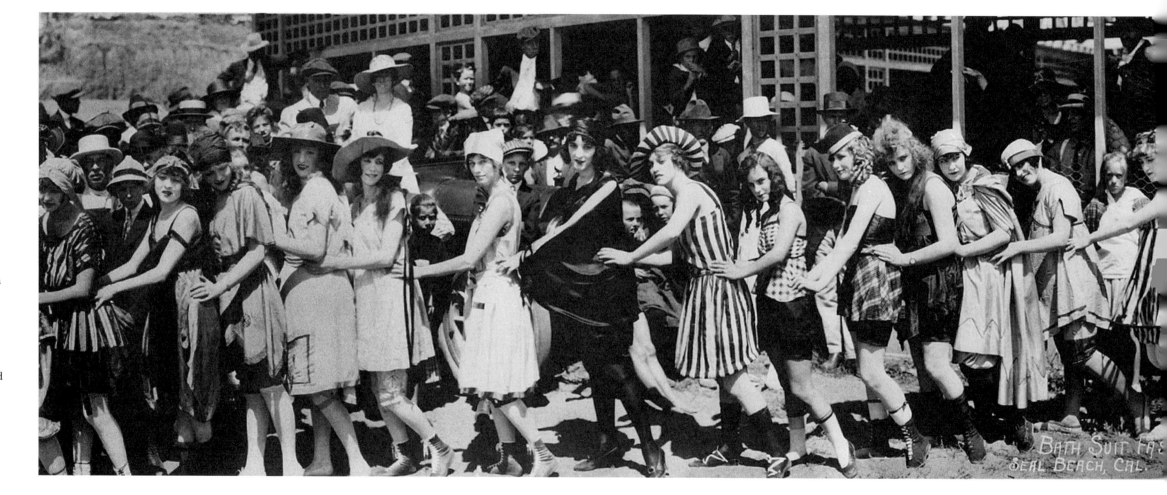

Seal Beach had been a summer recreation spot since the 1870s (first as Anaheim Landing, then as Bay City, before incorporating as Seal Beach in 1915). In the early twentieth century, State Assemblyman Phillip Stanton, the "father of Seal Beach," transformed the area from a sleepy stretch of shoreline into a destination for fun and games. Soon the city was boasting a "joy zone" with gaily lit piers and beachside amusements, which turned Seal Beach into an early Southern California tourist destination.

Seal Beach went through several cycles of downturns and upswings over the years. The worst of the downs occurred during the Great Depression, when it became a virtually lawless vice pit pegged as "sin city." Seal Beach would recover, and today it is the kind of thriving, family-friendly fun spot Stanton had dreamed of more than a century ago.

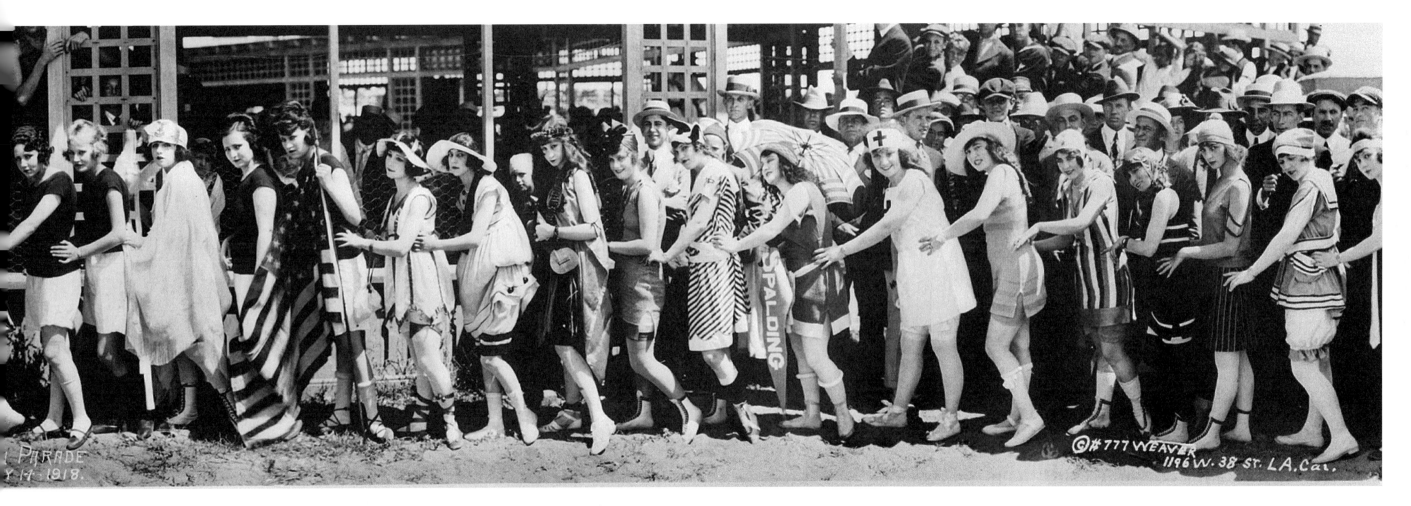

PARADE
Y 17 1918.

© #777 WEAVER
1196 W. 38 ST. LA. Cal.

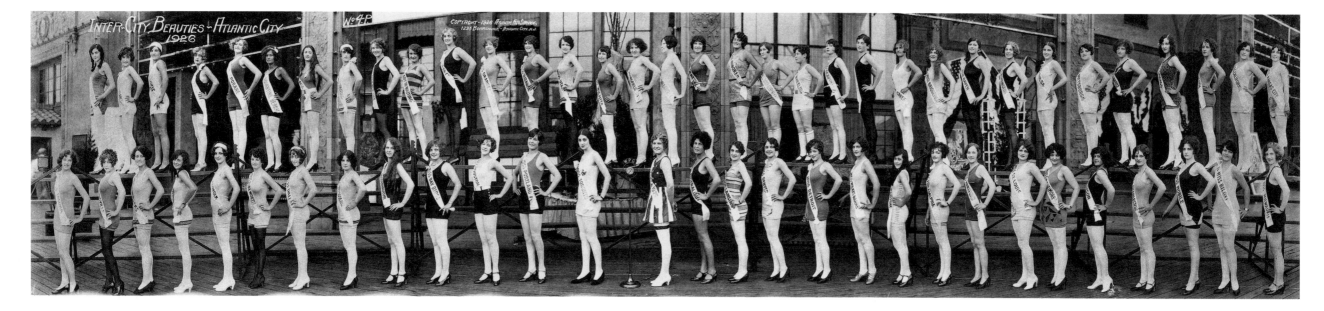

The year 1926 marked a breakthrough for the Miss America pageant when Norma Smallwood, a full-blooded Cherokee Indian, was the first non-Caucasian to win. This picture brings a flood of memories of what was, in many ways, a better time. I was brought up in Atlantic City in the 1940s and '50s (before the onslaught of gambling), when we rode our bikes to school and eagerly awaited the Miss America pageant and the arrival of true American Sweethearts. Everyone picked a favorite during the parade, and it really mattered who would be, as the song promised, "the queen of femininity." As the bathing suits got smaller, the talents less amazing, and the hype greater, the pageant became just another reality show. Things change, but fortunately, memories stay the same.

—Bill Persky

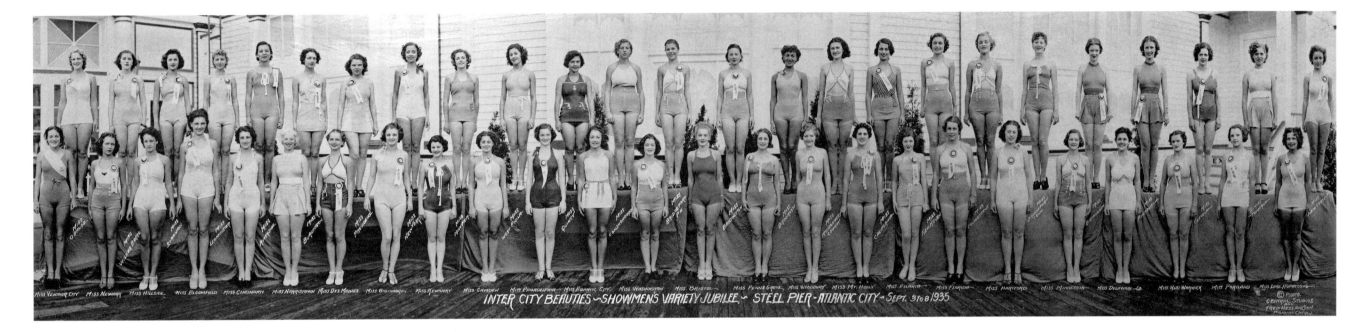

Atlantic City was already an established seaside resort by the 1860s and only grew more popular with the addition of its famed boardwalk in 1870. But Atlantic City's business was seasonal. Come Labor Day, the ocean waters would chill, business would begin to fall off, hotel rooms would empty, and the boardwalk booths would close up. Atlantic City's Businessmen's League came up with a plan to keep the tourists visiting in September: the Fall Frolic.

The high point of the Frolic was a parade of 350 attractive, costumed "maidens," who were pushed along the parade route in the wheeled wicker chairs that were a boardwalk fixture. The first Frolic—mounted in 1920—was such a success that it led to 1921's inaugural Inter City Beauty Contest. The winner of the contest was crowned Miss America. By 1927 the roll call of contestants had grown from the first year's twenty contestants to eighty-three from all over the country.

Although the contest was suspended for several years during the Great Depression, it resumed in the late 1930s, more popular than ever. By the 1950s the Miss America Pageant had become a lavish affair, and its audience had expanded from the thousands jammed into Boardwalk Hall to the millions with television sets.

Sadly, by the late 1950s, Atlantic City had lost its position as a prime tourist destination. Even the legalization of casino gambling in the 1970s could not turn the city around, and in 2006 the Miss America Pageant moved to Las Vegas.

The aesthete's term for amateur photography is "vernacular photography." Snapshots. They tantalize with their vagueness, their lack of provenance, their absence of any clue as to who, what, where. In the early days of amateur photography, there was something precious about each picture. Film was expensive; there were only so many shots per roll. Even the most casual backyard photo implied something—an act, a moment, a place, a person—worth remembering. Though this particular picture was likely a staged publicity photo rather than a friendly snapshot, it, like so many vintage photos, comes with no history—only its intriguing image.

Even before the advent of television, advertising men knew that few things were as effective at boosting sales as good visuals. There were print ads, but creative ad men were able to push their messages into the revues and variety stage shows that were very popular during the decades before television. Case in point: a line of leggy chorus girls dressed as bumblebees and touting Flit, the popular household insecticide. (Flit was actually intended for use against flies and mosquitoes, not bees.) Flit had been rolled out by a subsidiary of Standard Oil in 1923 and soon became one of the most recognizable names in household products.

In 1928 Theodor Geisel—in his pre–Dr. Seuss days—designed the artwork for a tremendously successful campaign that ran for seventeen years and made "Quick, Henry, the Flit!" a national catchphrase. Flit was dispensed through the iconic "Flit gun," the kind of hand-pumped sprayer one sees these days only in old cartoons. A 1929 ad featuring a Nutcracker Suite–style soldier pumping away with his Flit gun proclaimed, "Here's the Home Defender who stands side by side with the wise housekeeper!" It went on to brag that "Flit kills faster, and yet is perfectly safe to use, even around children"[15]—a boast that turned out to be sadly inaccurate. From the 1940s into the '50s, the Flit formula included the toxic insecticide DDT.

This fascinating piece shows the Side Show-Minstrel-Museum of the Hagenbeck-Wallace Circus—a circus second only in size to Ringling Brothers and Barnum & Bailey. This scene, taking place soon after the start of the Great Depression, reflects the relief and entertainment Americans could obtain simply by finding their way into a circus.

The sideshow featured people who may have had one leg, no legs, or no arms (and could draw with a pen in their mouth) or were extraordinarily overweight, thin, tall, or very short. But they were not "freaks" amongst their associates. Sideshows offered them a fabulous rich home: namely, contentment and security among their own people. Interestingly, if Houdini's wife, Bess, couldn't find him in the city, she had no trouble knowing where to look. If she found a circus in town with a sideshow, there was Houdini, sitting among the performers with whom he felt most at home.

In looking at this picture, you cannot help but be overwhelmed and saddened in some way that this part of show business is history. If one thinks about it, why shouldn't there be sideshows today? I would love to have spent time witnessing the richness and the joy, the quiet contentment and the dedication that each of these performers—oddities to the average person—possessed that made them stars. **—The Amazing Kreskin**

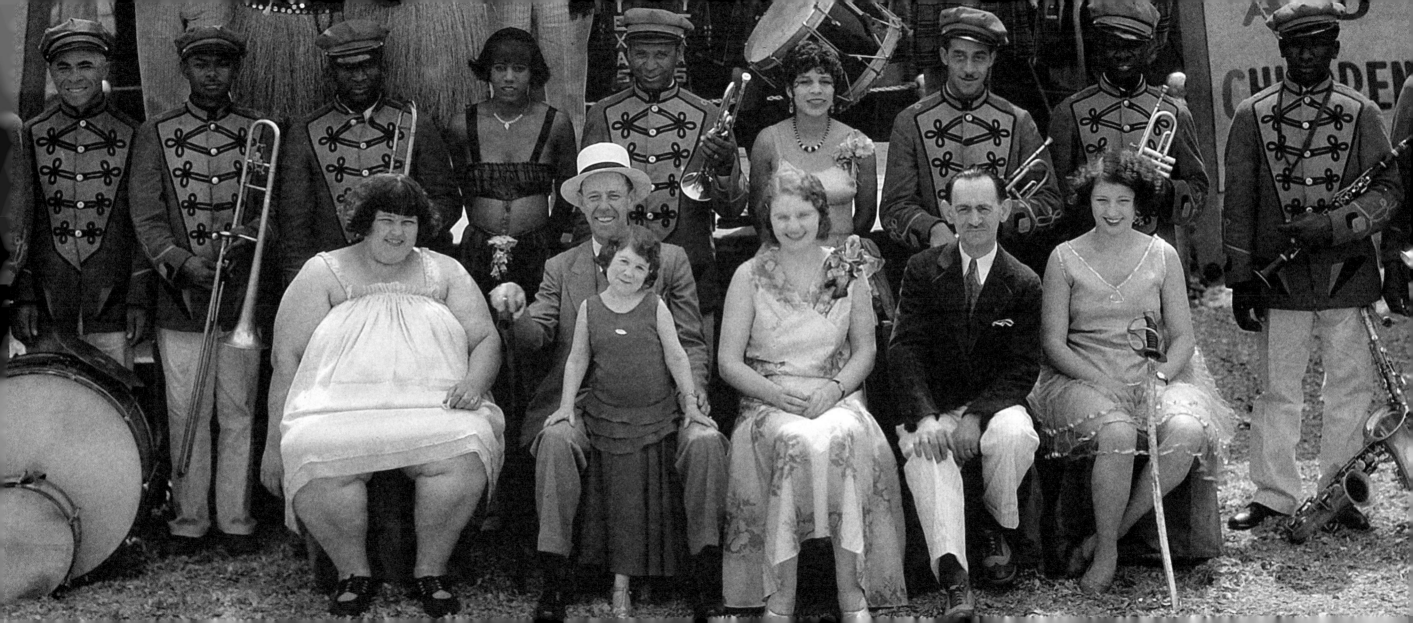

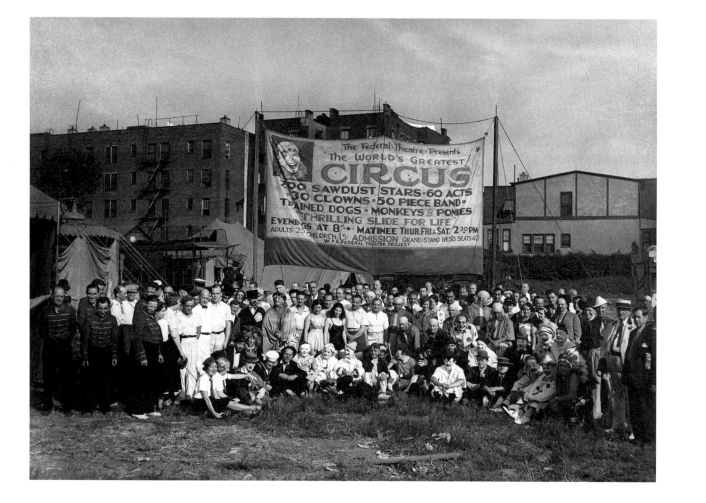

The Federal Theatre Project (FTP) was the only time the Federal government made a major investment in building a national theater program. It was one of President Franklin D. Roosevelt's Depression-era New Deal projects operating under the aegis of the Works Progress Administration (WPA) and dealt with two issues: the thousands of unemployed people in the arts and a public demoralized by economic devastation.

Established in 1935, the FTP produced live programs for the poor around the country, ranging from classic theater to vaudeville and even—as this photo shows—circuses. FTP touring groups went off into the nation's hinterlands, bringing the magic of live performance to rural communities that had never experienced a play or any other kind of live entertainment. It had been a founding hope that the FTP would establish a national base for the arts that would outlast the project, but Congress, displeased over what it considered left-leaning content in many FTP shows, canceled funding in 1939. **—Norman Lear**

OPPOSITE ⟶
James Pain Jr. was the descendant of a line of gunpowder and fireworks manufacturers going back to late sixteenth-century England. In 1879 he conceived the "pyrospectacular," a combination epic performance and grand-scale pyrotechnics display. Mounted in Pain's Amphitheatre in Coney Island, the spectacle drew thousands, who would watch actors play out scenarios against a backdrop of elaborate fireworks displays and opulent sets that would be destroyed in re-creations of historical disasters, such as the "Last Days of Pompeii." Today, audiences are treated to the same kind of thrilling devastation, only now created by masters of computer-generated imagery.

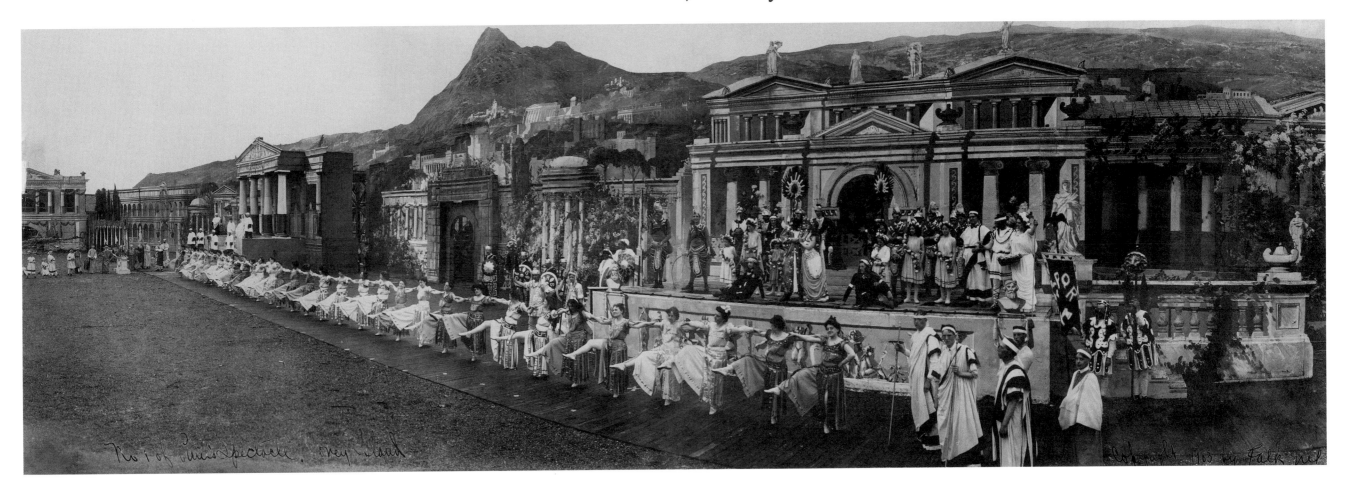

While one could easily argue that "little people" still must strive to be thought of as individuals defined by more than their height, their situation was certainly more distressing decades ago. Viewed at best as curiosities, at worst as freaks, these people found that the professional avenues open to them typically were limited to carnival freak shows, the circus, and the occasional mainstream appearance (in *The Wizard of Oz*, for example). Another avenue of employment came in the form of exploitative shows that placed these entertainers in miniaturized settings: movies such as the 1938 musical Western *The Terror of Tiny Town*; "midget villages," including Lilliputia at Coney Island's Dreamland; the 1933 Century of Progress Chicago World's Fair, which showcased "sixty Lilliputians [who] live in their tiny houses,...serve you with food, and entertain you";[16] and stage performances, such as the Midget Swing Revue at the 1939 Dallas State Fair. Even at their most innocuous, such displays were demeaning, giving a paying audience something to point at rather than bridging differences.

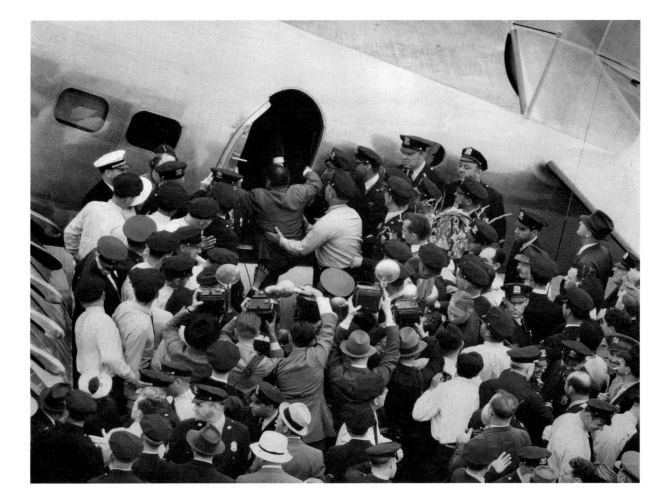

We think of the paparazzi—the hounding horde of press photographers—as a contemporary phenomenon. The word itself, derived from an Italian word for a buzzing mosquito, was coined from a character's name in filmmaker Federico Fellini's 1960 classic *La Dolce Vita*. But crowds of intrusive lensmen had long been established by then, as this photo—probably from the 1930s or '40s—indicates. Unlike today's paparazzi, who tend to be freelancers selling their images to the highest bidder, the paparazzi of old were more often staff photographers from a then-vibrant print media: newspapers and a host of mainstream movie-star and celebrity-gossip magazines.

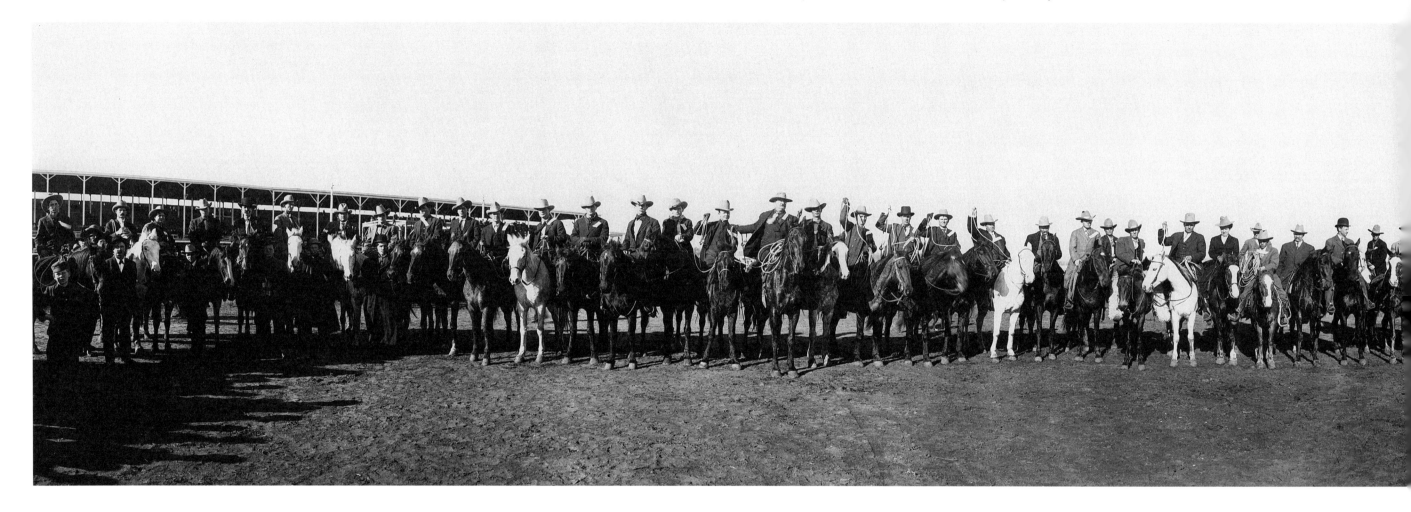

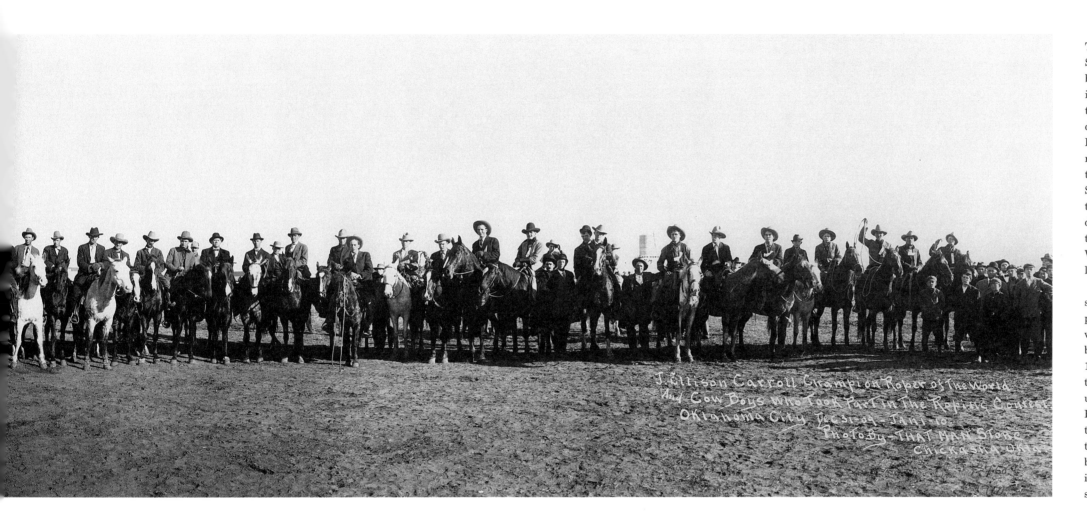

J. Ellison Carroll Champion Roper of The World
And Cow Boys who Took Part in The Roping Contest
Oklahoma City Dec 31-09 - Jan 1 to
PhotoBy THAT MAN Stone
Chickasha Okla

The cowboy walking tall in spurred boots, his Stetson pulled low on his head, skilled at bronco bustin', bull ridin', 'n' calf ropin' is a true American icon. But both the cowboy and the rodeo have their roots in what is now the American Southwest during a time when the area belonged to Mexico. Even the word "rodeo" is Spanish and originally referred to regular gatherings of Mexican *rancheros* to round up and separate cattle and horses. The Southwest became part of the United States after the Mexican-American War, and Anglo cattle drovers (the word "cowboy" was not generally used to describe these ranch hands until after the Civil War) picked up the skills, the garb, and even the lingo of their Mexican counterparts, the *vaqueros*.

Because the job of a ranch hand was so reliant on a specific set of skills and physical prowess, informal competitions between ranches were a natural by-product. These contests become widely popular in the West by the mid-1880s. Although no one is sure when and where the first formal rodeo took place, historians usually point to an 1883 event in Pecos, Texas. By 1929 the largest rodeo organizers had come together to form the Rodeo Association of America to standardize competitions. The rodeo has since become bigger and glitzier, but at its core it is still about recognizing the same skills that served the cowboy a century and a half ago.

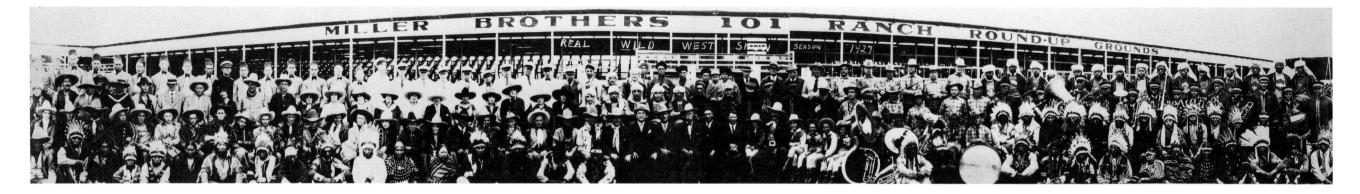

ABOVE

The mystique of the Old West and its iconic images of cowboys, shoot-outs on the dusty streets of frontier towns, and pioneer wagons fending off Indian attacks had a powerful hold on the American psyche well into the twentieth century. After all, in the early 1900s, the Old West was not that old—Oklahoma, New Mexico, and Arizona were still territories. But while memories of the Old West were still strong, its prime had long since passed. The American cowboy had become an endangered species by the 1880s, as the expanding reach of railroads negated the need for long cattle drives.

Still, the country was not willing to give up the legend of the Old West lightly,

and Wild West shows not only kept it a live but brought a small—if often hyperbolic— picture of it to their audiences. There were a number of these traveling spectacles, including the Miller Brothers 101 Ranch Wild West Show, based out of a working cattle ranch.

Eventually, the movie Western filled the role of the Wild West show. The Miller Brothers 101 Ranch show, one of the longer lasting, limped along until 1939. By the late twentieth century, the Old West had become old enough to be all but forgotten. Youngsters no longer fantasized about riding the range but of piloting spaceships and hunting zombies.

OPPOSITE ⟶

By the late twentieth century, ostentatious displays of patriotic fervor had become more divisive than unifying. The Vietnam War had left the country polarized, and flag waving—literal and metaphorical—became symbolic of an antiquated form of jingoism. Even today, despite the sadly transitory unifying effect of 9/11, how high the flag is raised and how fervently it is saluted have become antagonizing stand-ins for love of country.

There was, however, a time when displays of patriotism were both natural and

free of accusations. This was particularly true after World War I. The United States had displayed both its might and its righteousness on the international stage and emerged from the conflict as one of the world's great military and economic powers. It was as if we, as a nation, needed the war to become aware of our great abilities to produce, to defend ourselves at a global scale, and to protect our overseas allies. With the benefit of a century's hindsight, this confidence may seem boastful, but at the time, we felt we had a lot to boast about.

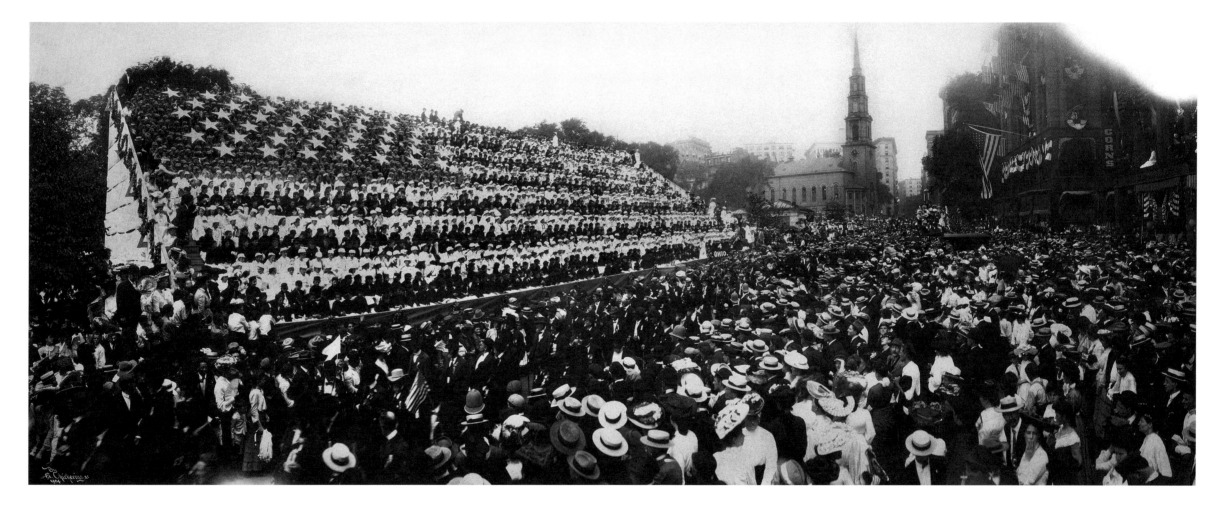

LEISURE

The rule of my life is to make business a pleasure, and pleasure my business. —Aaron Burr

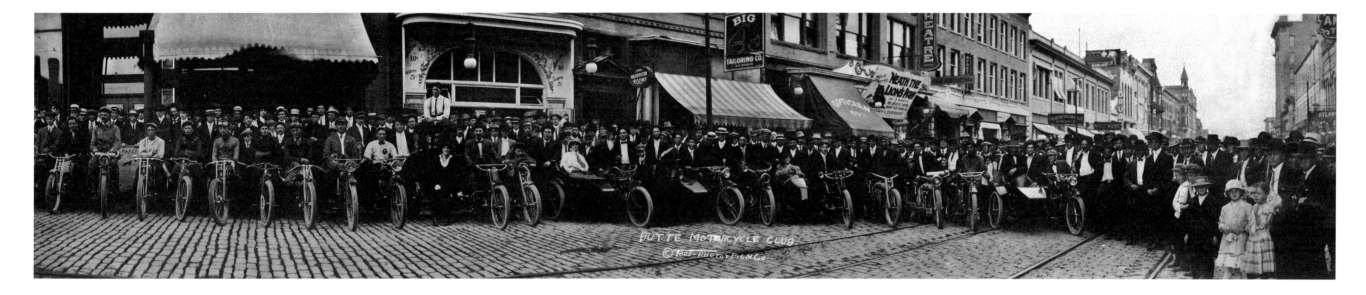

The first steam-powered bicycle was invented in 1863. From then on, bicycle makers and tinkerers dallied with wedding the bicycle to a power source, ultimately settling on the internal combustion engine in the 1880s.

It was the inventor of the new vehicle, E. J. Pennington, who coined the term "motor cycle." In 1901 Indian Motorcycle—the first motorcycle manufacturer in the United States—began producing motorcycles for the public and by World War I was the largest maker of motorcycles in the world. Indian Motorcycle folded in 1953, temporarily, leaving Harley-Davidson as the sole American brand in a field that by the late twentieth century was increasingly dominated by foreign imports. Other American companies started making motorcycles in the next decades, and Indian went back into production in the new millennium, as the appeal of motorcycles broadened in the United States.

The citizens of Butte took a special interest in the motorcycle as a sign of the city's comparative sophistication. This photograph was taken at a time when the horse and wagon was still a fixture throughout the western part of the United States.

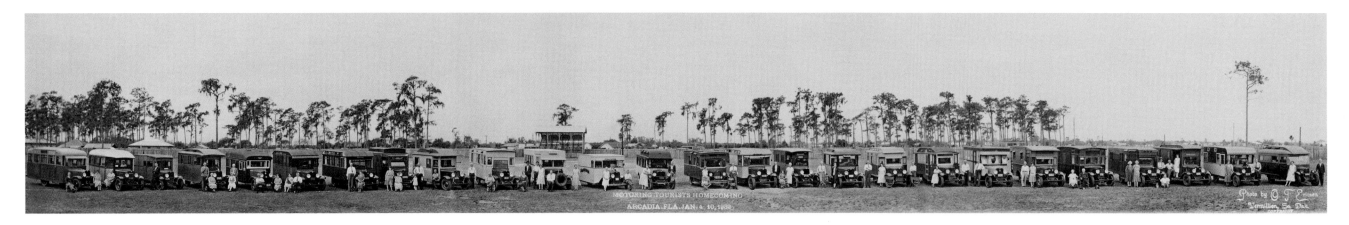

The American love of the open road existed long before the interstate highway system was built in the 1950s. In fact, it goes back to the days when there wasn't much road to love. From the time the first Model Ts rolled off Henry Ford's production lines in 1908 and early drivers discovered the hardy Tin Lizzie's capability for negotiating the most deeply rutted, mud-holed, unpaved tracks, "Let's go for a ride" became something of a national motto and obsession, despite gas selling for the equivalent of almost $4.50 per gallon.

The Tin Can Tourists—so-called for the soup cans covering their radiator caps— came together to enjoy road travel en masse. Organized in Florida in 1919, group members gathered at seasonal rallies with their homemade trailers, house cars, and tents, sometimes forming camps of more than a thousand vehicles in a kind of fellowship of the road. The rallies lasted into the 1980s; then, in 1998, the organization was revived in Michigan and continues to this day.

It was ironic that President Barack Obama asked me to lead the process of restructuring the American automobile industry, because as a longtime resident of Manhattan, I rarely drove and had only a passing interest in cars.

But even though my job was to burrow into the numbers and figure out how to fix the companies, I couldn't help but be captivated by the place that the automobile has in the history and culture of the United States. I saw it on my numerous trips to the Motor City of Detroit, even more centered on automobiles than New York is on finance. I felt it as I got to know real "car guys," for whom automobiles were almost organic creatures, more alive to them than pets. And so for me, to see a vintage photograph that illustrates America's love affair with cars nurtures my own appreciation for their centrality in our lives. **—Steve Rattner**

Dinner for French Admiral Paul Campion at Delmonico's — *New York, New York, May 2, 1906*

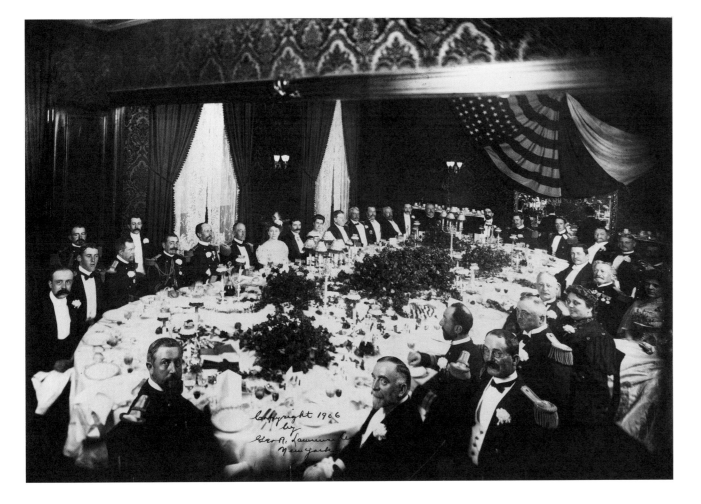

My grandfather, Oscar Tucci, reopened New York's famous restaurant Delmonico's—appropriately renaming it "Oscar's Delmonico"—in the late 1920s. Although there are many photographs of the restaurant, including those of special dining events and celebrity-caliber guests, few capture the elegance my grandfather created in a building that would otherwise most likely have been torn down.

If only cameras could have captured more panoramic photos of the marvelous dinners my grandfather held and of the legendary diners who celebrated with a grandeur that still impresses today. Oscar's Delmonico was often graced by Oscar's friends, such as Greta Garbo, Zsa Zsa Gabor, Gypsy Rose Lee, and Red Buttons. Nobles, dignitaries, presidents, royalty—they, too, dined at my grandfather's establishment. He hired men that he knew would succeed in the industry, including now-famous restaurateurs, from Sirio Maccioni of Le Cirque, whose own

career in fine dining began when he was a busboy at Delmonico's, to San Domenico's Tony May, whose career began just as humbly when he was a waiter for the very people who, years later, would number among his patrons.

The stories are many and endlessly entrancing, from serving eight hundred lunches a day to the first compact ticker-tape machine placed on the famous bar; from Oscar creating what is known today as the "wedge salad" to using "Delmonico money" to purchase alcohol during prohibition to employing the first lady ever to work a till. Photographs or no, the stories of Oscar Tucci and his son (my father) Mario Carlo Tucci saving, reestablishing, operating, owning, and entertaining at Oscar's Delmonico at 56 Beaver Street in New York City still pass down from one generation of the Tuccis to the next, as permanent and legendary as the name Delmonico's. **—Max Tucci**

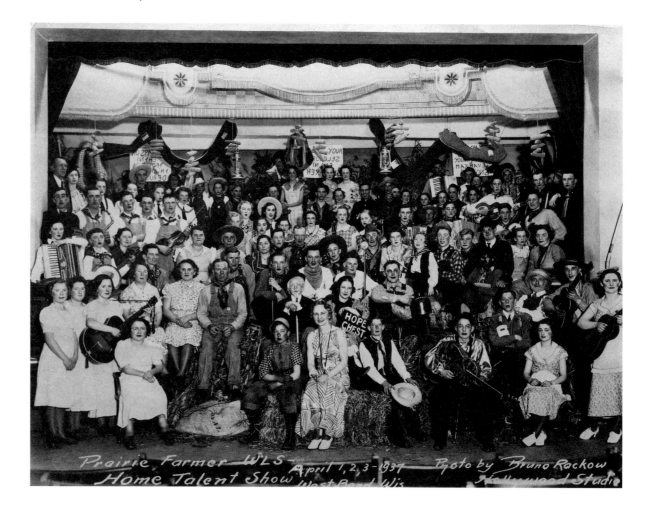

At the very beginning of the broadcast era, there was a delightful, distinguishing parochialism to a mass media that, at the time, was not very massive. Case in point: Chicago-based WLS radio. The station, launched in 1924 by retailer Sears, began in the earliest days of commercial radio as WBBX and hoped to use the station to foster its connection with its rural, Midwestern mail-order customers. In 1928 Sears sold the station to Prairie Farmer, a magazine with an eighty-year history of serving rural and farming audiences.

For the next thirty-two years, the renamed WLS offered its agrarian listeners a mix of farm-targeted news—livestock and produce reports, weather reports—and country folk–flavored entertainment, ranging from corn-husking contests to National Barn Dance, an especially popular variety show. National Barn Dance featured talent such as the singing cowboy Gene Autry and musical groups that included the Prairie Ramblers and the Cumberland Ridgerunners. WLS's biggest coup: reporter Herbert Morrison's emotionally charged account of the 1937 Hindenburg disaster ("Oh, the humanity!"). To reinforce the bond between station and audience, Prairie Farmer produced an annual photo album featuring WLS artists, staff, and even staff families, putting faces to the voices and names known by its devoted audience.

By the end of the 1950s, programmers increasingly focused on more profitable urban and suburban audiences. WLS was absorbed by the American Broadcasting Company and transformed into one of the most notable Top Forty rock 'n' roll stations of the 1960s and '70s. The station is still on the air in an all-talk format.

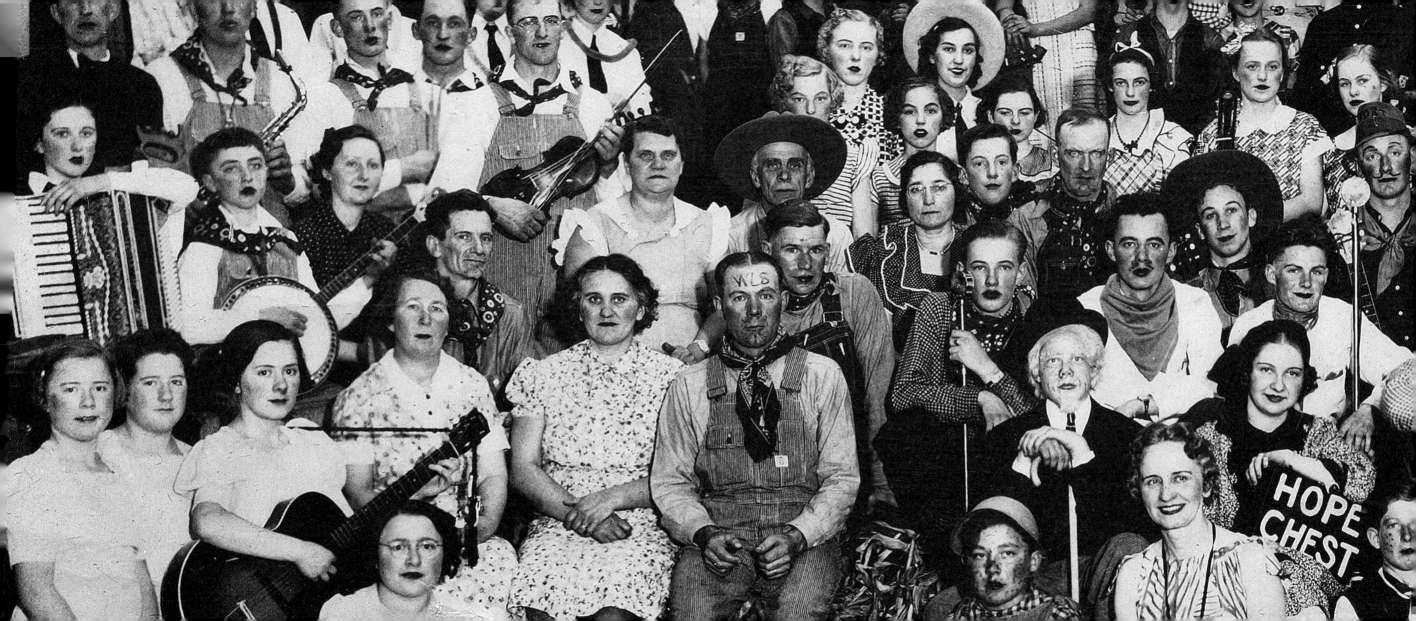

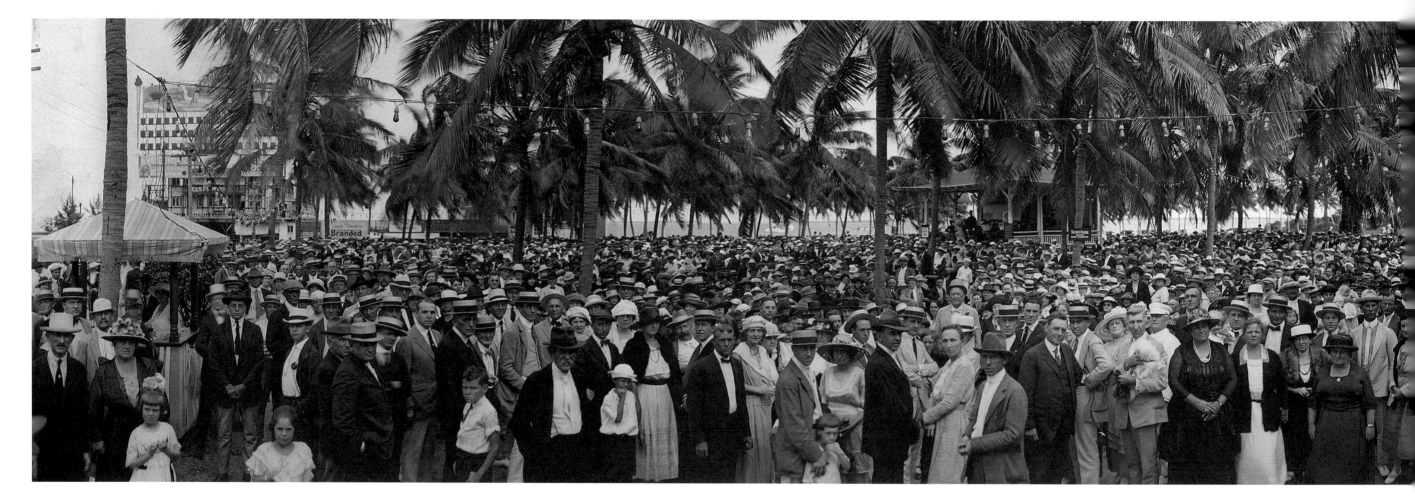

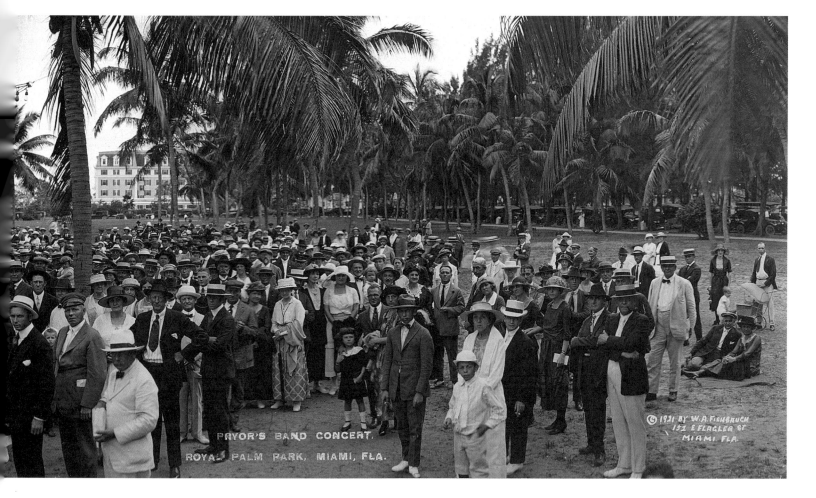

PRYOR'S BAND CONCERT,
ROYAL PALM PARK, MIAMI, FLA.

© 1931 BY W.A.FISHBAUGH
151 E.FLAGLER ST
MIAMI, FLA

Throngs of rabid fans are not unique to rock or other modern-day performances. Although contemporary listeners might find musicians like John Philip Sousa quaint, with their high collars and slicked-down, center-parted hair, the music men of Sousa's time were the rock stars of their day. And in the early twentieth century, few rocked like Arthur Willard Pryor.

Born in a Missouri theater to a musical family, Pryor was predestined to be an entertainer. He picked up a trombone left to pay a debt to his father and became not only one of the music stars of the era but one of the all-time great trombonists. Still in his twenties, Pryor first played for Sousa's band and then set out with his own group in 1903. How popular was the Pryor Band?

During a series of 269 concerts played in Asbury Park, New Jersey, the Pryor Band played to a total of more than three hundred thousand people.

Although he retired from public performing while still in his forties, he continued to work as a composer and bandleader. He died of a stroke after a rehearsal: a fitting end for a man literally born in the theater. What would have been the best epitaph for Pryor was written in a reporter's account of one of his performances: "His vibrating pedal tones rattled the windows of the Theatre and killed the gold fishes and stunned the canaries all the way out to the packing plant where even the iron gates trembled."[17]

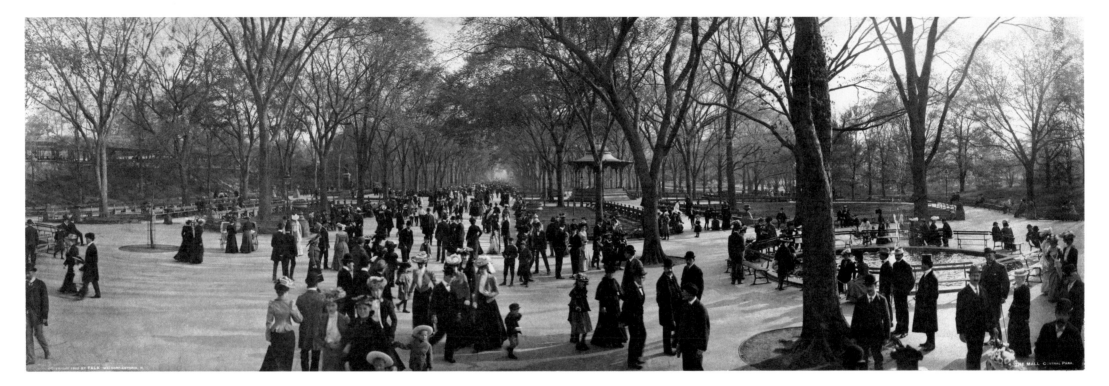

Visiting Central Park at the turn of the twentieth century was a much more formal occasion than it is today. The clothing styles that you see in this photo signify the importance of being seen in public in what was considered proper attire. The self-segregated groups of single men and women also show the stricter adherence to social custom at that time.

One of the more fashionable places to be seen and to see others in New York City was the Mall in Central Park. The statues along Literary Walk depict prominent contributors to English literature of the last four hundred years. The walkway is adorned at one end by Olmsted Flower Bed, a tribute to Frederick Law Olmsted, one of the park's designers, and at the other by Bethesda Terrace and Fountain. From the beginning, the north end of the Mall has been a popular spot to meet with friends to begin an afternoon exploring the park's 843 acres.

One thing that has not changed in the last century is the importance that the most diverse city in the United States places on attractive natural settings as gathering places for recreation or relaxation. **—Henry Stern**

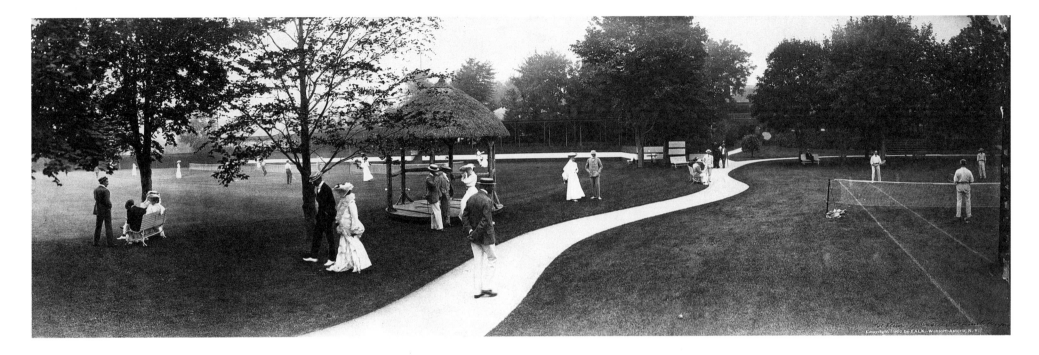

Mark Twain's 1873 novel *The Gilded Age* provided an apt name for the last decades of the nineteenth century. It was a period of unmatched economic growth for the United States and spawned a generation of American tycoons who lived by the motto: "If you got it, flaunt it!" The Breakers, a palatial "summer cottage" built by the Vanderbilts in Newport, still stands as a perfect example of Gilded Age excess.

Another by-product of the new moneyed class was the country club, a private enclave where the wealthy could retreat and relax among their own kind. The Newport Casino— which wasn't really a casino—was built in the 1880s and became a rather tragic gauge of the country's economic health. It was a beautiful complex of wood-frame buildings, but after the Panic of 1893—which effectively ended the Gilded Age—the resort began to suffer and was in a serious state of deterioration by the 1950s. The Casino still stands, somewhat restored and now home to the International Tennis Hall of Fame (the resort had been host to tennis tournaments since it opened), an oft-ignored reminder that hubristic booms are inevitably followed by humbling busts.

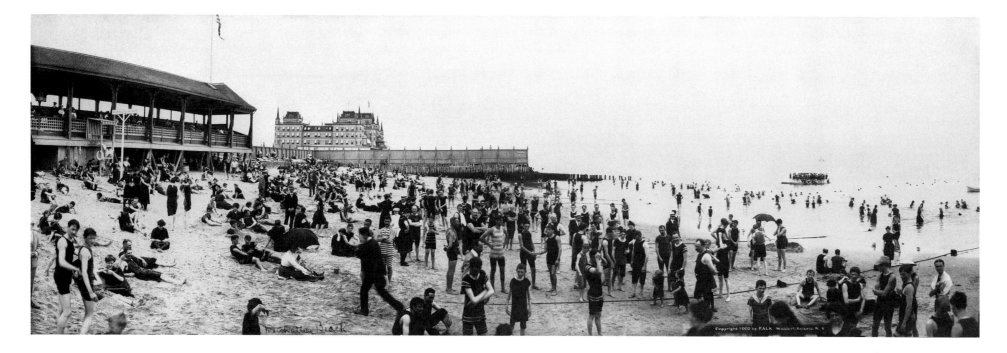

The peninsula called—in the kind of quirk in which New Yorkers take an odd pride—Coney Island was, in the early nineteenth century, a sleepy seaside community. By the end of that century, on a rising tide of entrepreneurial investment, the neighborhoods of Coney Island—including Manhattan Beach—were becoming the playground of the world.

Even today, Coney Island's turn-of-the-century amusement parks—Luna Park, whose brilliant nighttime lightscapes dazzled at a time when many homes still did not have electricity; Dreamland, whose Lilliputian Village was populated by three hundred dwarves; Steeplechase Park, the oldest and longest lasting of the three, with its Steeplechase Horses, a kind of roller coaster/horse race—dazzle with their ingenuity and audacity. Luna Park was financially hobbled by the Great Depression, then suffered a series of fires in the early 1940s and finally closed in 1944; Dreamland was destroyed by fire in 1911; and Steeplechase went through a number of ups and downs until it closed in 1964. The parks may be gone, but the name Coney Island has never lost its magic. It is in itself an attraction, still luring investors and redevelopers looking to bring back some of that lost dazzle.

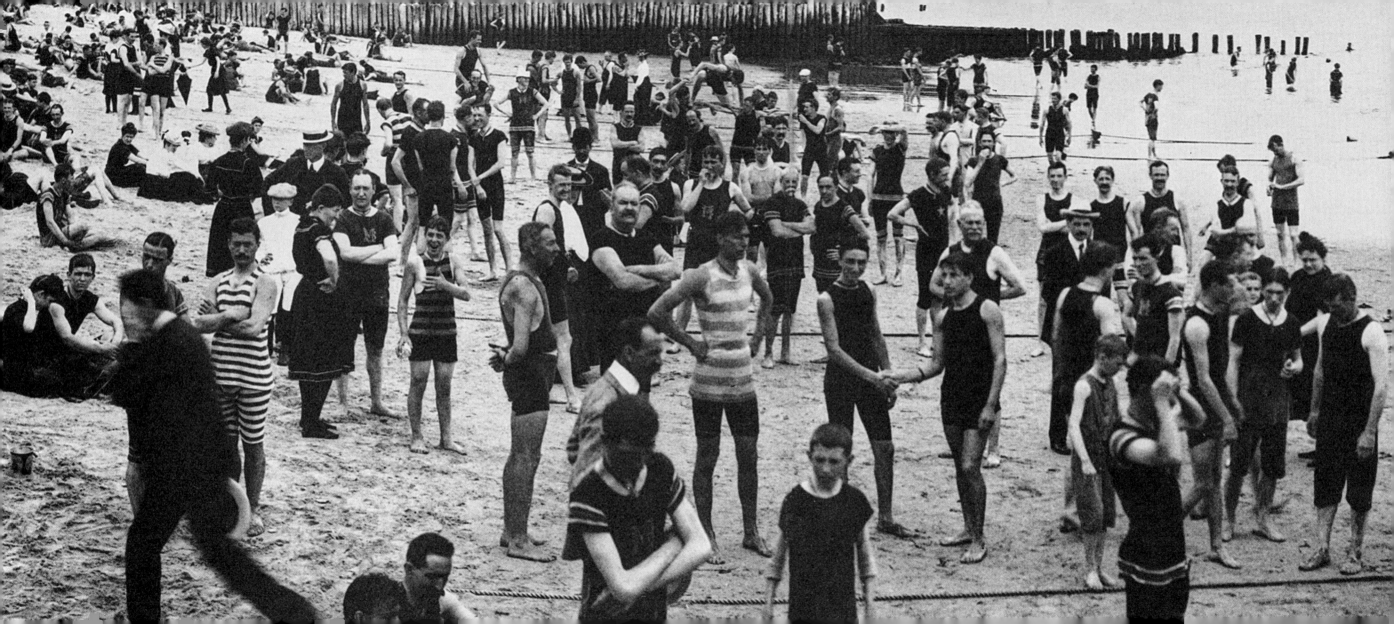

SPORTS

If a tie is like kissing your sister, losing is like kissing your grandmother with her teeth out. —George Brett

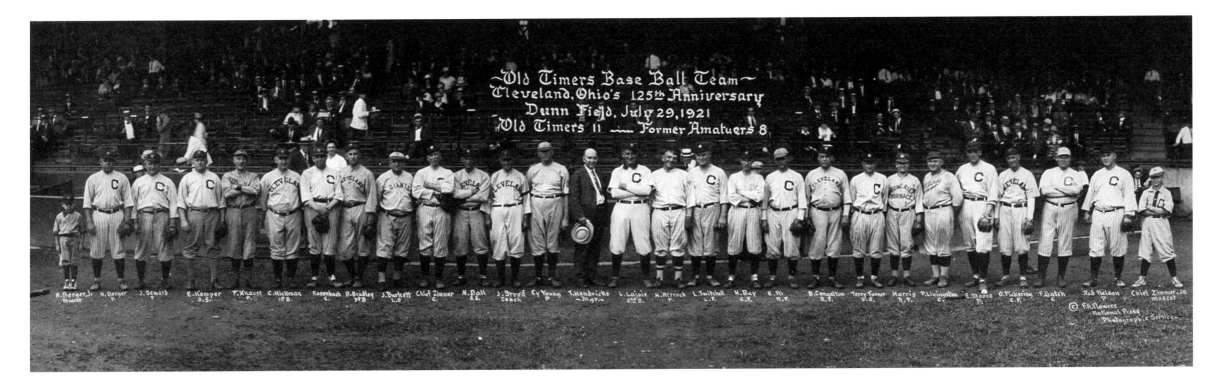

These guys are older than me. A lot older, since this photo was taken four years before I was born. Nice thing about this group of old Cleveland guys is that it's an early Old-Timers' Day—one of the best traditions in baseball. It's always been one of my favorite days, as a player and as an Old-Timer myself. The Yankees made it an annual event, starting in 1946. Today they're the only team to still celebrate it—I never miss it. Back when I played, they'd bring in non-Yankee greats like a Ty Cobb or Dizzy Dean. Cy Young, probably the greatest pitcher ever, is in this photo. When I met him at one of our Old-Timers' Days in the early 1950s, he was a really old Old-Timer. But he was still Cy Young. **—Yogi Berra**

Despite its homey name and appearance, People's Drug, founded in 1904 and based in Alexandria, Virginia, a suburb of Washington, DC, was the CVS of its day: an aggressively expansive discount chain that, by the 1920s, seemed to have a store in every DC neighborhood. (The chain was itself absorbed by CVS in 1990.) People's Drug did, however, have all the accoutrements of old-time local drugstores, offering everything from soda-fountain counter service to medicines and personal products, ranging from Bucho Buttons, for kidney problems, and Graham's Blood Purifier to Walnutta hair stain.

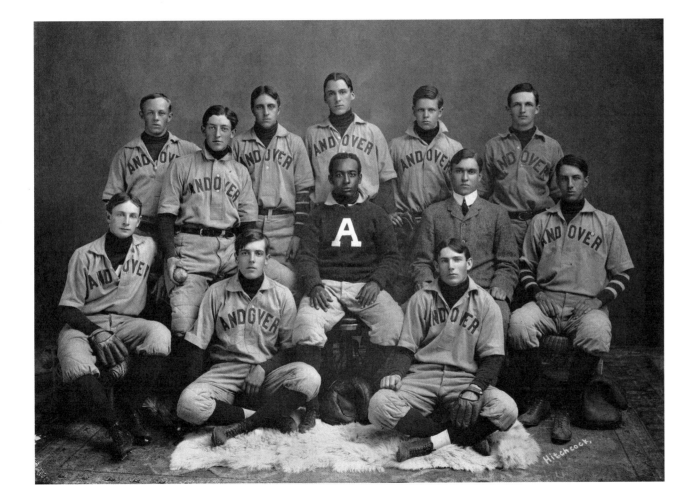

Phillips Academy Andover, the oldest incorporated academy in the United States, was founded in 1778 during the Revolutionary War, three years before Phillips Exeter Academy's appearance just twenty miles away in New Hampshire. Although the two schools are noted for their football rivalry—one of the oldest in scholastic football—they have, in fact, always shared the idea that sports and athletic accomplishment are part of a well-rounded education. They have also always shared a nobility of purpose in their founding principles. On the school's seal, designed by Paul Revere, is the motto *Non sibi* (not for one's self). At the center of the photo (in the Andover sweater) is William Clarence Matthews, who was captain of the Andover baseball team in 1901. Matthews went on to Harvard, and later was the only African-American baseball player in the minor-league Northern League, and probably the only one playing professionally with whites in the United States at a time when baseball was strictly segregated.[18]

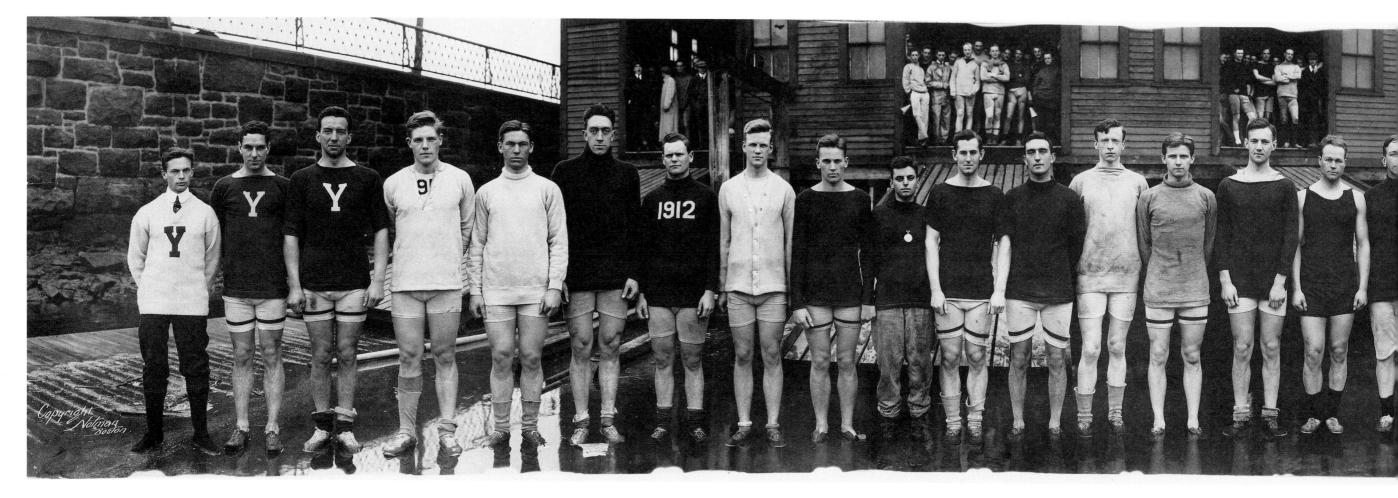

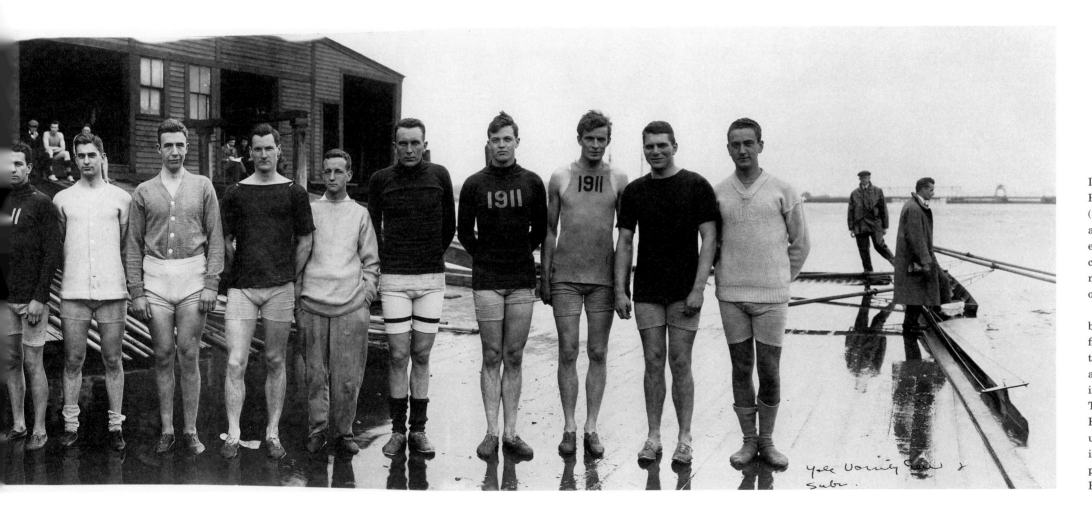

Yale Varsity Crew &
Subs.

It is almost as if Yale has never forgiven
Harvard for being the first American university
(founded in 1636, sixty-five years before Yale)
and Harvard has never forgiven upstart Yale for
equaling the older school's luster. That would
certainly explain the two schools' centuries-old,
more-or-less friendly jockeying to outdo each
other in both academics and athletics.

The Game—as the ongoing football feud
between Yale and Harvard, dating back to their
first scrimmage in 1875, is called—may be
the most storied competition in collegiate sports
as well as one of the most prominent contests
in this legendary rivalry, but it is not the oldest.
That honor goes to the Harvard-Yale Regatta.
Harvard may have been the country's first
university, but Yale fielded the first collegiate crew
in the United States in 1851. The following year—
predictably, some might say—Yale challenged
Harvard, and they have been at it ever since.

Riverview Military Academy football team — *Poughkeepsie, New York, 1895*

Until the United States converted to an all-volunteer military in 1973, the bulk of its fighting men—from the Civil War through Vietnam—were draftees. Even during the Great Crusade of World War II, approximately half of the fifteen million men who served were draftees. Citizen soldiers were sufficient to fill out the ranks, but the need for a skilled cadre of professionals has always been clear. To that end, the US government launched the first of its service academies, West Point, in 1802 (followed by the Navy's Annapolis in 1845 and the Air Force Academy in 1954).

The attraction of the military's mix of discipline, honor, and tradition has long extended beyond the service academies. Since the early eighteenth century, private high schools and even elementary schools have modeled themselves after the service academies.

The Riverview Military Academy in Poughkeepsie was one such school. Founded in 1836 as the Poughkeepsie Collegiate School, the academy introduced military training into its curriculum during the Civil War. A year after the end of the war, the school officially renamed itself a military academy and took on all the trappings of a sort of junior West Point.

Many of these private academies could not weather the antimilitary sentiments stirred up by the Vietnam War, and a number of them closed during the 1970s. Riverview, however, had shut its doors long before that, and in the 1920s, its grounds and buildings were taken over for use as a community center.

There was a time when talking football meant talking college football, and only college football. Until the late 1950s, and a boost from televised games, professional football was the sport's poor relation. Before then, real football was college football. After all, the game had been born on college campuses in the mid-nineteenth century, when it was referred to as "the Boston game," and by the 1920s it was the most popular spectator sport in certain parts of the country, particularly the South.

The first intercollegiate game was between Rutgers and Princeton in 1869, setting the stage for the longest rivalry in college football, but the most iconic ongoing duel was—and remains—the Army-Navy game. Army-Navy has always been more than a collegiate athletic competition, right from the academies' first face-off in 1890. There's a reason it's called Army-Navy and not West Point-Annapolis; with teams fielded by the Army's US Military Academy (i.e., West Point), and the US Naval Academy (i.e., Annapolis), Army-Navy was and is as much about an interservice rivalry dating back to the earliest days of the republic as it is an athletic contest. (The match even has its own trophy: the Thompson Cup.) Because of the physical requirements for military service, the academies haven't always produced the strongest teams in the collegiate conferences, but in terms of the heart and pride they put on the field, Army-Navy has always numbered in the top ranks. —**Roger Staubach**

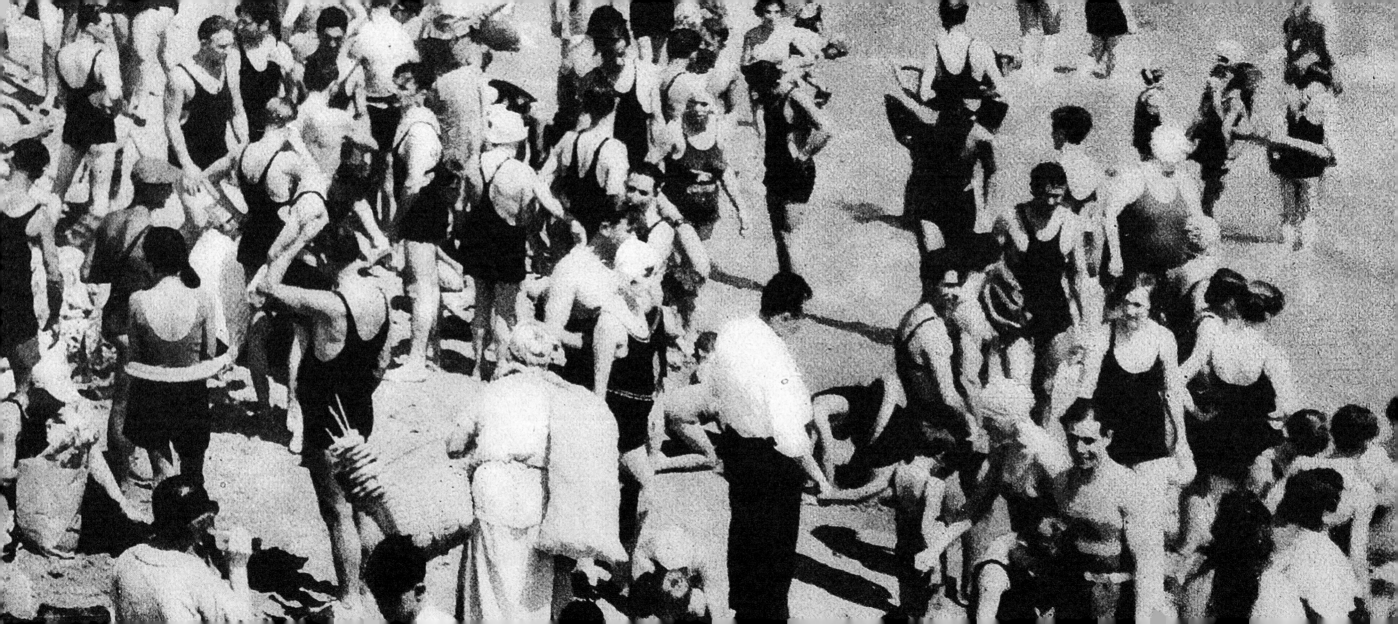

BIBLIOGRAPHY

Bogdan, Robert. *Adirondack Vernacular: The Photography of Henry M. Beach.* Syracuse, NY: Syracuse University Press, 2003.

Burleson, Clyde W., and E. Jessica Hickman. *The Panoramic Photography of Eugene O. Goldbeck.* Austin: University of Texas Press, 1986.

Harris, David. *Eadweard Muybridge and the Photographic Panorama of San Francisco, 1850–1880.* Montreal: Centre Canadien d'Architecture, 1993. Distributed by MIT Press.

MacKay, Robert B. *America by the Yard: Cirkut Camera Images from the Early Twentieth Century.* New York: W. W. Norton, 2006.

Rosenblum, Naomi. *A World History of Photography.* New York: Abbeville Press, 1997.

Wilmerding, John. *American Art.* New York: Penguin Books, 1976.

NOTES

1 George F. Cotterill, "Welcome to the City," in *National Electric Light Association Thirty-Fifth Convention*, vol. I (National Electric Light Association, 1912), Archive.org, http://archive.org/stream/conventionvolum00convgoog/conventionvolum00convgoog_djvu.txt.

2 San Joaquin Valley Geology, "The Lakeview Gusher," http://www.sjvgeology.org/history/lakeview.html (accessed January 17, 2013).

3 City of Galena, "History," http://www.cityofgalena.org/history.cfm (accessed January 17, 2013).

4 "Mayor Proclaims Advertising Week," *Old Penn Weekly Review*, June 24, 1916.

5 "Advertising Clubs Open Convention," *New York Times*, June 27, 1916.

6 National Aeronautic Association, "Awards," http://naa.aero/html/awards/index.cfm?cmsid=57.

7 Phillips Exeter Academy, "The Original Deed of Gift from John Phillips to Phillips Exeter Academy, Containing the Constitution, May 17, 1781," http://www.exeter.edu/documents/The_Original_Deed_of_Gift.pdf.

8 First Christian Church, "Values and Beliefs," http://firstchristian.info/about/values/ (accessed January 13, 2013).

9 Triumph the Church National, "Church History," http://www.triumphthechurchnatl.org/ChurchHistory.htm (accessed on January 17, 2013).

10 Sherry Sherrod DuPree, *African-American Holiness Pentecostal Movement: An Annotated Bibliography* (New York: Routledge, 1995), 157.

11 *Report of the Eighteenth Annual Lake Mohonk Conference on National Arbitration* (Lake Mohonk Conference on International Arbitration, 1912), 23, Archive.org, http://archive.org/stream/reportstdannual09unkngoog#page/n28/mode/2up.

12 PBS.org, "WWI Casualty and Death Tables," http://www.pbs.org/greatwar/resources/casdeath_pop.html (accessed January 18, 2013).

13 Frank Henry Goodyear, *Red Cloud: Photographs of a Lakota Chief* (Lincoln, NE: University of Nebraska Press, 2003), 37.

14 The Pythians, "The Pythian Story," http://www.pythias.org/index.php?option=com_content&view=article&id=56:the-pythian-story&catid=41:about-the-order&Itemid=27 (accessed January 22, 2013).

15 Advertisement in *Good Housekeeping*, August 1929.

16 *Official Guide Book of the Fair* (Chicago: A Century of Progress, 1933), 121, accessed at Archive.org, http://archive.org/details/officialguideboo00centrich.

17 Willow Grove Park, "Arthur Pryor Biography," http://www.wgpark.com/page.asp?pid=22 (accessed January 25, 2013).

18 Karl Lindholm, "William Clarence Matthews, a Baseball Pioneer," *Historic Roots: A Journal of Vermont History* 1, no. 2 (August 1996): 10–19.

CREDITS

2–3 Inscription (not pictured): "Annual Banquet of the Sons of the Revolution in the State of New York, Delmonico's, Feb. 22, 1906"; detail. Geo. R. Lawrence Co., Chicago, IL; Library of Congress, Washington, DC

15 Inscription: "Omaha Merchants Express and Transfer Co." Frederick J. Bandholtz, Des Moines, IA; Library of Congress, Washington, DC

16 Tool room of the National Cash Register Co., Dayton, Ohio. Geo. R. Lawrence Co., Chicago, IL; Library of Congress, Washington, DC

17 Inscription: "Train De Luxe from New York, En Route N.E.L.A. Convention at Seattle, 1912, Shasta Springs, Calif. Wagner, Quality." Wagner Electric Co., Saint Louis, MO; Library of Congress, Washington, DC

18 Inscription: "Keyes Dairy." Photographer unknown; W. M. Hunt collection

19 Cincinnati, Hamilton & Dayton Railroad shops. Photographer unknown; W. M. Hunt collection

20–21 Inscription: "Mr. H. M. Flagler and party leaving first train to arrive at Key West, Fla. Oversea Florida East Coast R. R., Jan. 22-12." Harris Co.; Library of Congress, Washington, DC

22–23 Inscription: "Red-Jacket concrete-bridge dedication. Aug. 22-11." John R. Snow, Mankato, MN; Library of Congress, Washington, DC

24 Inscription: "Members of American Iron and Steel Institute; inspecting the ore docks, Cleveland, October 23, 1915." The Miller Studio, Cleveland, OH; Library of Congress, Washington, DC

25 Visit of San Francisco Stock Exchange officials to the famous Lake View Gusher. Pacific Photo & Art Co., San Francisco, CA; Library of Congress, Washington, DC

26–27 Ground breaking for the Japanese concession at the Panama-Pacific International Exposition. W. Wesley Swadley, San Francisco, CA; Library of Congress, Washington, DC

28 Inscription: "Wreck on I.C.R.R. near Farmer City, Ill. Oct 6th, '09." International Stereograph Co., Decatur, IL; Library of Congress, Washington, DC

29 Inscription: "Blackjack Mine, Galena, Ill. Operated by Mineralpoint Zinc. Co." The Lighty Photo Co., Williamsport, IN; Library of Congress, Washington, DC

30–31 Inscription: "Panoramic picture of Armour & Co.'s General Office, Union Stock Yards, Chicago." Geo. R. Lawrence Co., Chicago, IL; Library of Congress, Washington, DC

32 Unidentified crowd. Photographer unknown; W. M. Hunt collection

33 Farmers. Photographer unknown; Josh Sapan personal collection

34–35 Inscription: "Office and factory staff, The Fisher Body Ohio Co'y Cleveland Ohio September 21, 1926." The Morchroe Co, Cleveland, OH; W. M. Hunt collection

37 Inscription: "Annual Shad Bake of the District of Columbia Bar to Bench, Chesapeake Beach MD. May 13, 1916." Schutz Group Photographers, Washington, DC; Library of Congress, Washington, DC

38 American Newspaper Publishers Association. Geo. R. Lawrence Co., Chicago, IL; Library of Congress, Washington, DC

39 Inscription: "Eleventh Annual Dinner/Erie Railroad Association/Hotel Savoy, New York, Feb. 23, 1906." Geo. R. Lawrence Co., Chicago, IL; Library of Congress, Washington, DC

40–41 Associated Advertising Clubs of the World at Convention Hall. Caywood, Bell & Fischer, Philadelphia, PA. Library of Congress, Washington, DC

42 City of Bridgeport Police Department. Henry J. Seeley, Bridgeport, CT; Library of Congress, Washington, DC

43 Central Files staff of the National Recovery Administration. Schutz Group Photographers, Washington, DC; Library of Congress, Washington, DC

44–45 Inscription: "TPA/Forty-Third Annual State Convention/Virginia Division/Newport News VA/May 15-16, 1936." Photographer unknown; W. M. Hunt collection

46 Inscription: "Actors on 45th St." Bain News Service, New York, NY; Library of Congress, Washington, DC

47 Inscription: "First Annual Banquet/Federation of American Aero Clubs/Tendered by Aeronautique Club of Chicago/Feby 21, 1908." Geo. R. Lawrence Co., Chicago, IL; Library of Congress, Washington, DC

CONTRIBUTORS

Joseph Abboud took his first job in fashion as a sixteen-year-old part-timer. Twenty years later he launched his own label and became the first designer to win the Council of Fashion Designers of America's Best Menswear Designer of the Year award two years running.

Attorney **Dan Abrams** is the chief legal analyst for ABC as well as a substitute anchor for *Good Morning America*. He is also the head of the digital-media strategy firm Abrams Research, publisher of a half-dozen web properties, and the best-selling author of *Man Down: Proof Beyond a Reasonable Doubt that Women Are Better Cops, Drivers, Gamblers, Spies, World Leaders, Beer Tasters, Hedge Fund Managers, and Just About Everything Else.* As a reporter for CourtTV, he covered a number of high-profile cases, including the O. J. Simpson trial, and took MSNBC to high ratings and profits during his 2006–7 stint as the general manager.

A show business legend, **The Amazing Kreskin** has made countless TV appearances, written sixteen books, and logged more than three million miles performing around the world displaying his mentalist abilities. He also acts as a consultant to law enforcement and security personnel, helping them develop their own powers of observation.

Yogi Berra—nicknamed in childhood because of his resemblance to a Hindu holy man—was an eighth-grade dropout (he left school to help support his family) who went on to become one of major league baseball's most accomplished and beloved players. Berra played in fourteen World Series, holds several Series records, won ten championships, and is rated as one of the best catchers who ever played professional baseball. His "Yogi-isms—"such as "It ain't over 'til it's over"—are one of his trademarks.

Three-time Emmy winner **Dick Cavett** hosted late-night's *The Dick Cavett Show*, televised on ABC, PBS, the USA Network, and CNBC. His shows were hailed for their wide variety of guests, their frequent controversies, and Cavett's ability to attract "ungettable" guests. His most recent book, *Talk Show*, is a collection of his blog posts, written for his online *New York Times* column of the same name.

Labeled by *New York* magazine as the "last of the Madison Avenue wild men," **Donny Deutsch** built Deutsch, Inc., into one of the country's top ten advertising agencies. He is familiar to most people, however, as the former host of CNBC's *The Big Idea with Donny Deutsch* and regularly appears on MSNBC's *Morning Joe* and NBC's *Today* show.

Mark Halperin has spent nearly twenty-five years covering politics, working his way up from researcher for ABC's *World News Tonight* to his current positions as editor at large and senior political analyst for *Time* magazine and senior political analyst for MSNBC. With journalist John Heilemann, he wrote the 2010 best seller *Game Change: Obama and the Clintons, McCain and Palin, and the Race of a Lifetime*, adapted by HBO into a 2012 award-winning film.

After graduating summa cum laude and Phi Beta Kappa from Brandeis University with a degree in literature in 1974, **Christie Hefner** began working at Playboy Enterprises, the company founded by her father, Hugh Hefner. By 1982 she was running it and continued to do so until stepping down in 2009. She currently works with Canyon Ranch to extend its brand and knowledge about health and wellness and with organizations interested in philanthropic and progressive causes.

Arianna Huffington is a nationally syndicated columnist and the author of "thirteen books. In May 2005 she launched the *Huffington Post*, a news and blog site that quickly became one of the most widely read, linked, and frequently cited media brands on the Internet. In 2012 the site won a Pulitzer Prize for national reporting.

Raymond Kelly has a number of impressive credits on his resume: among them Vietnam combat veteran (first lieutenant in the Marines); corporate global-security chief; and commissioner of US Customs during the Clinton administration. He is most prominently identified as the longest-serving police commissioner of the New York City Police Department (NYPD), first serving under Mayor David Dinkins between 1992 and 1994 and under Mayor Michael Bloomberg since 2002. Kelly has spent a total of forty-three years as a member of the NYPD.

Bob Kerrey received the Congressional Medal of Honor for his service as a Navy SEAL in Vietnam between 1966 and 1969. He would later become Nebraska's thirty-fifth governor, serving from 1983 to 1987, and a senator for Nebraska between 1989 and 2001. From 2001 to 2011, he was the president of New York City's renowned university The New School.

Norman Lear revolutionized TV in the 1970s with a series of provocative comedies, including *All in the Family*, *Sanford and Son*, *Maude*, *The Jeffersons*, and *One Day at a Time*, that grappled with the issues of a tumultuous time, winning four Emmys in the process. Lear would later move into film producing, with projects such as *This Is Spinal Tap*, *Stand by Me*, and *The Princess Bride*. He has also long been a civil liberties advocate, founding People for the American Way in 1981.

Representative **John Lewis** is the US congressman representing Georgia's Fifth District since 1987 and the dean of Georgia's congressional delegation. He first joined the National Association for the Advancement of Colored People (NAACP) at the age of fifteen after hearing a speech by Martin Luther King Jr. on the radio. As a college student during the 1960s, he participated in the sit-in movement, serving as a leader in the Nashville Movement, the Selma to Montgomery march, and the Student Nonviolent Coordinating Committee. He was also one of the original thirteen Freedom Riders who desegregated interstate bus terminals during the 1960s and was beaten and arrested more than forty times for his efforts. He is the last surviving speaker from the March on Washington and is often called "the conscience of the US Congress."

A nationally recognized civil rights and criminal-defense attorney, **Peter Neufeld** cofounded the Innocence Project in 1992. The organization is dedicated to using DNA evidence to exonerate the wrongly convicted and has, to date, participated in the exoneration of most of the three hundred defendants they have represented, including seventeen prisoners on death row.

A member of the Comedy Hall of Fame and a six-time Emmy winner, writer/producer/director **Bill Persky** has worked on some of the most iconic TV series, including *The Dick Van Dyke Show*, *That Girl*, and *Kate & Allie*. He has just penned his first book, a memoir entitled *My Life Is a Situation Comedy*.

Beginning as a reporter for the *New York Post* in 1974, **Anna Quindlen** would go on to write—as reporter, essayist, pundit, and columnist—for the most influential newspapers and magazines in the United States. She has also become a best-selling author of fiction and nonfiction. In 1992 she became the third woman to receive the Pulitzer Prize for commentary.

As President Obama's "car czar," financier **Steve Rattner** was the administration's leading advisor on the restructuring of the American automobile industry. He is currently chairman of Willett Advisors and is a regular contributor to the *New York Times* op-ed section and the *Financial Times*. He is also an economic analyst for MSNBC's *Morning Joe*.

Pro Football Hall of Famer **Roger Staubach** was the quarterback for the Dallas Cowboys from 1969 to 1979 and led them to their first Super Bowl victory (Super Bowl VI), earning himself the MVP award for the game. One of football's biggest stars throughout the 1970s, Staubach retired from the game in 1980.

Henry Stern's career in public service extends back more than half a century. Among his many notable accomplishments are his service as a New York City councilman (1974–83) and as the Commissioner of Parks and Recreation under Mayor Ed Koch (1983–90) and Mayor Rudolph Giuliani (1994–2000).

In the years following the publication of her book *Entertaining* in 1982, **Martha Stewart** made herself the preeminent worldwide brand name in home keeping. She founded Martha Stewart Living Omnimedia, a media and merchandising company with award-winning magazines, apps and digital properties, television programming, and products for the home. She is one of the most recognizable names in media and popular culture.

For twenty years **Lawrence Summers** has held a number of high-ranking policy-making positions in the field of economics, including chief economist at the World Bank, secretary of the treasury for the Clinton administration (1999–2001), and the Obama administration's director of the National Economic Council. In 1993 he received the American Economic Association's prestigious John Bates Clark Medal for his work in economics. He is currently a Charles W. Eliot University Professor at Harvard, where he served as president from 2001 to 2006.

TV and radio personality, chef, lifestyle expert, fashion designer, photographer, and one of "New York's 100 Most Eligible Bachelors," according to *Gotham* magazine, **Max Tucci** is the grandson of restaurateur Oscar Tucci, who revived the legendary Delmonico's name in 1927.

Since her breakout role as the seductive Matty Walker in 1981's steamy *Body Heat*, **Kathleen Turner** has gone from sex icon to respected film, TV, and stage actress. She has earned Tony nominations for her work in a 1990 revival of *Cat on a Hot Tin Roof* and a 2005 revival of *Who's Afraid of Virginia Woolf?*

American fashion designer **Kay Unger** graduated from Parsons School of Design and went on to found three clothing companies, including Phoebe Company LLC and its various brands, such as the upscale Kay Unger New York. In 1999 she was named one of the Leading Women Entrepreneurs of the World. Unger left the company in 2012 to focus on philanthropic efforts, particularly the Steven Julius Foundation, which she created that year.

ACKNOWLEDGMENTS

This book is a testament to a panorama of talent. I will always be grateful to Luc Sante for his words; Bill Mesce for help beyond syntax; W. M. Hunt for his generosity; Christopher Sweet, Greg Pasternack, and Susan Peirez for shaping the book; Thérèse Duval for editing, managing, and enduring; and Patrick Montgomery and James Danziger—photo gurus and patient counselors. Thank you to Robert B. MacKay, Paul Wagner, Elana Schlenker, Penelope Santana, and Jessica Johnson for all their help and Jennifer Lippert, Sara Stemen, and Sara Bader for being wise publishers.

Published by
Princeton Architectural Press
37 East Seventh Street
New York, New York 10003

Visit our website at www.papress.com.

Developmental Editor: Christopher Sweet
Contributing Editor: William Mesce
Project Editor: Sara E. Stemen
Designer: Elana Schlenker
Prepress: Greg Pasternack

Special thanks to: Meredith Baber, Sara Bader,
Nicola Bednarek Brower, Janet Behning, Fannie Bushin,
Megan Carey, Carina Cha, Andrea Chlad, Barbara Darko,
Benjamin English, Russell Fernandez, Jan Hartman,
Jan Haux, Diane Levinson, Jennifer Lippert, Katharine Myers,
Emily Johnston-O'Neill, Margaret Rogalski, Dan Simon,
Andrew Stepanian, Paul Wagner, and Joseph Weston
of Princeton Architectural Press
—Kevin C. Lippert, publisher

Library of Congress Cataloging-in-Publication Data

Sapan, Joshua.
The big picture : America in panorama / Josh Sapan ;
introduction by Luc Sante.
pages cm
Includes bibliographical references.

ISBN 978-1-61689-165-7 (hardcover : alkaline paper)
1. United States—History—Pictorial works.
2. United States—History—1865—Pictorial works.
3. Photography, Panoramic—United States. I. Title.
E178.5.S25 2013
973.0022'2—dc23

2013000417